D1305177

POSTCARD HISTORY SERIES

Stratford

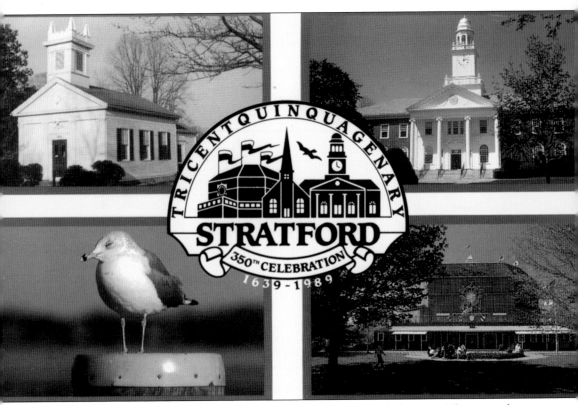

Seen here are Putney Chapel, the town hall, and the American Shakespeare Theatre as they appeared on the town's 350th anniversary in 1989. (Note the sleepy ring-billed gull on the riverfront piling.)

POSTCARD HISTORY SERIES

Stratford

John D. Calhoun and Lewis G. Knapp
for the Stratford Historical Society

ARCADIA
PUBLISHING

Copyright © 2004 by John D. Calhoun and Lewis G. Knapp
ISBN 978-0-7385-3579-1

Published by Arcadia Publishing,
Charleston, South Carolina

Printed in the United States of America

Library of Congress Catalog Card Number: 2004101540

For all general information, contact Arcadia Publishing:
Telephone 843-853-2070
Fax 843-853-0044
E-mail sales@arcadiapublishing.com
For customer service and orders:
Toll-free 1-888-313-2665

Visit us on the Internet at www.arcadiapublishing.com

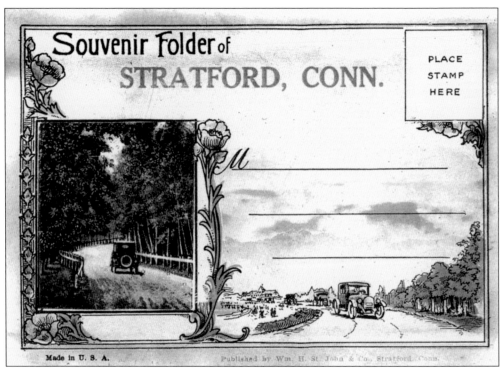

In the early 1900s, picture postcards were important vehicles for sending messages. William St. John created his own scenes of Stratford and even packaged them in folders for sale in his drugstore.

CONTENTS

ACKNOWLEDGMENTS

The majority of the images that make up this postcard history of Stratford are from the archives of the Stratford Historical Society. The archives include postcards from the collections of Howard Lounsbury and Raymond Cable. Many of the aircraft views are from the collection of coauthor Lewis G. Knapp. We thank Carol Lovell for sharing her postcards.

Special thanks go to Marie Blake and Vivienne Knapp for their help in organizing and editing the images and text.

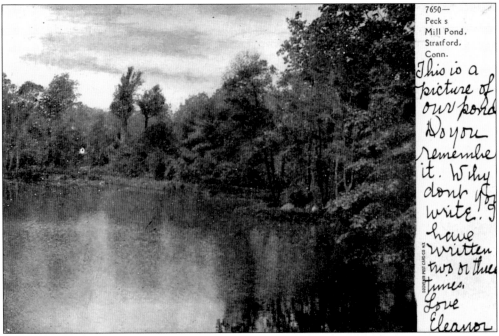

From 1684, when James Blakeman built the first mill here, to 1912, when the last mill ceased operating, pastoral Peck's Mill Pond served as a millpond, ice pond, and fish hatchery. Today it is a town park preserved for fishing in the summer and ice-skating in the winter.

INTRODUCTION

In the early 20th century, people kept in touch with friends and relatives through letters and postcards. Phone calls were expensive. Postcards offered an economical way to say a brief "Having a wonderful time" or "Why haven't you written?" Postcards also encouraged exchanging and collecting pictures of all kinds. Many Stratford shops, such as St. John's Drug Store, published their own selected views of Stratford. Hundreds of different images were offered.

We are fortunate that a few postcard collections were saved. Earlier views of the town, its character, its businesses, and its activities were preserved. This postcard history portrays many of the special features that make Stratford unique, such as its aircraft industry, the American Shakespeare Theatre, and the many activities on the Housatonic River and the sound.

The aircraft industry has been a vital part of the Stratford scene since 1929, when Igor Sikorsky began production of his flying boats in his factory on the river. The Sikorsky helicopter plant is now Stratford's largest employer. The Chance Vought Corsair fighter plane was also produced in Stratford during World War II.

For many years, top professional casts played the American Shakespeare Theatre. They lived in Stratford during the theater season, and many cast members are fondly remembered. Memories of the theater and its players are captured in these vintage postcards.

The Housatonic River and Long Island Sound have always been central to Stratford life. Recreational boating, fishing, and commercial oystering are all portrayed in postcard images.

Stratford's participation in the area-wide army maneuvers in 1912 is little known. A major force was stationed in large open areas of Paradise Green. Today these areas are covered with homes. In all, 20,000 troops were deployed. Visitors toured the encampments, and hundreds of photographs were taken.

Stratford residents and visitors collected postcards illustrating the important aspects of town life. Schools, churches, municipal buildings, and civic organizations were all documented. Views of popular shops and restaurants bring back memories. We hope that you enjoy this postcard history and that perhaps you will come to a greater appreciation of these historic collections.

A century ago, Main Street was unpaved, but it was laid with trolley tracks, shaded by graceful elms, and lined with houses that were ancient even then. An exception was the home designed by eminent architect Bruce Price and built by John Sterling for his mother and sisters in 1886. Today, Sterling House is a community center.

One

SERVING OUR TOWN

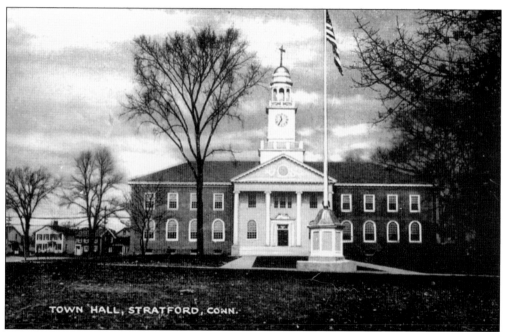

TOWN HALL, STRATFORD, CONN.

With over 30,000 residents during the Great Depression, Stratford sorely needed more town facilities. Our independent town leaders finally accepted a $200,000 Public Works Administration grant, and on February 1, 1937, our new town hall, designed by architect Wellington Walker, opened for business.

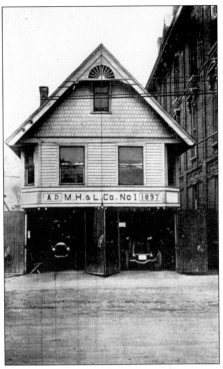

In 1897, the all-volunteer Mutual Hook and Ladder Company moved out of the basement of the old town house and into its new building next to the town hall on Main Street. A hand-drawn ladder truck and a hand-operated pump wagon were the company's first apparatuses. By the time of this photograph, the company owned two fire trucks.

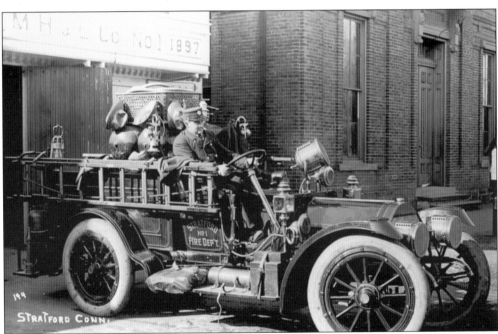

In April 1911, the Mutual Hook and Ladder Company added its first motorized fire engine to its roster. The sparkling red auto-chemical fire engine had a 40-horsepower engine, two tanks of chemicals, a basket of hoses, two extension ladders, seats for two, and standing room for six. It was built in next-door Bridgeport at the Locomobile Company. Here Chief Allan Judson, Stratford's only paid fireman, drives it from the two-bay firehouse.

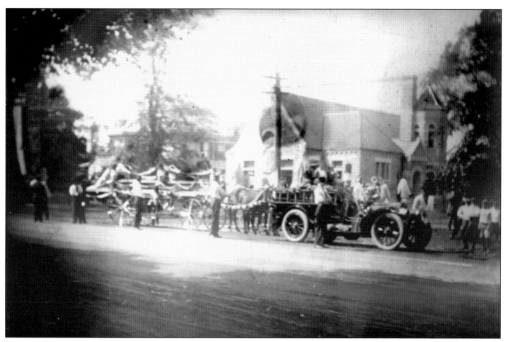

On Decoration Day (now Memorial Day), Engine No. 1 led the parade. Here the apparatus waits in front of the library, probably on the town's 275th anniversary in 1914, for the grand marshal to signal the start.

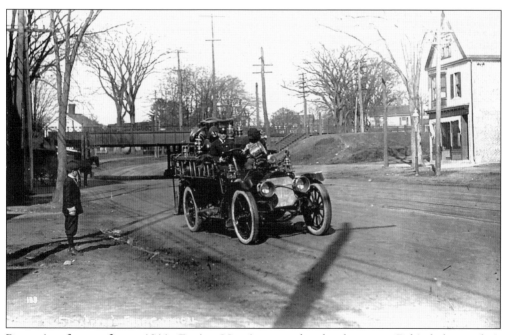

Returning from a fire *c.* 1911, Engine No. 1 approaches headquarters. Behind the truck is the railroad viaduct, and the trolley tracks to Paradise Green and Shelton are on Main Street underneath. John Assum's bakery hides the railroad station on the right.

Stratford Library and the Abijah McEwen homestead bracket the lane to the Congregational Burying Ground on a tree-lined Main Street. It is a quiet summer morning in the early 1900s.

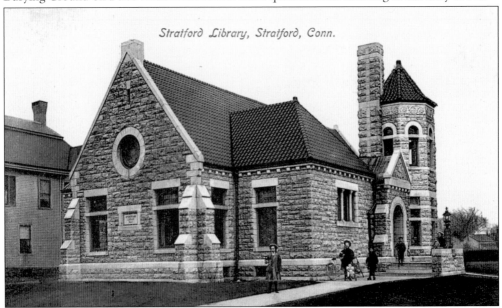

In 1896, a brand-new library sits in the summer sun. Donated by New York publisher Birdseye Blakeman and built of St. Lawrence marble, the library had stacks, a reading room, and 4,000 books. Fanny Russell was head librarian until 1958. The Stratford Library Association is a state-chartered corporation.

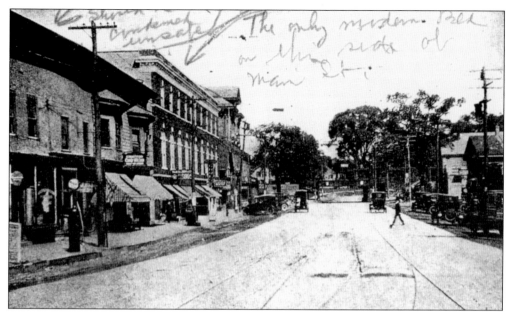

By 1920, Stratford Center was a thoroughly modern business center. On the left are the Tuttle Building, built in 1912, and Harold Lovell's block, built in 1919–1920. On the right is John Assum's bakery, which went up in 1911.

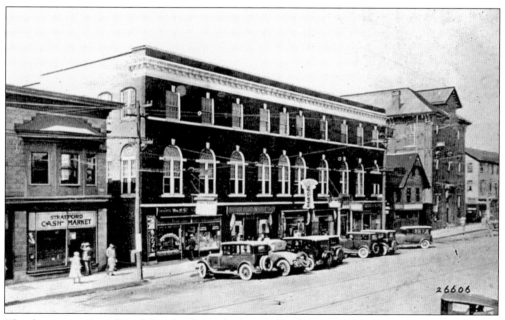

The three-story Lovell Building has been the largest block in Stratford Center since it opened in 1920. The building originally housed a large hardware store, a druggist, and a clothing store at street level, offices and meeting halls on the second floor, and apartments on the third floor. It also holds the first freight elevator in town. This scene is from the 1920s.

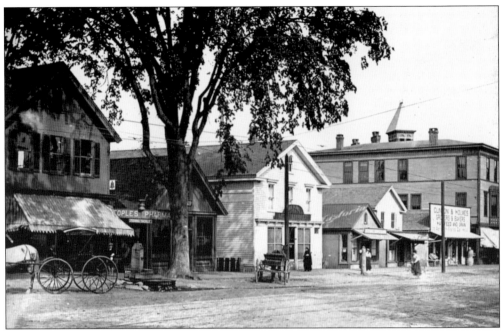

In 1911, horse–drawn vehicles ruled Stratford Center. Groceries, bakeries, pharmacies, and news stores served customers who came by foot, carriage, bicycle, and, rarely, motorcar. Professional offices and social clubs rented upper floors of buildings in the area. Some merchants owned carts and wagons for home delivery of meat, groceries, bread, and ice.

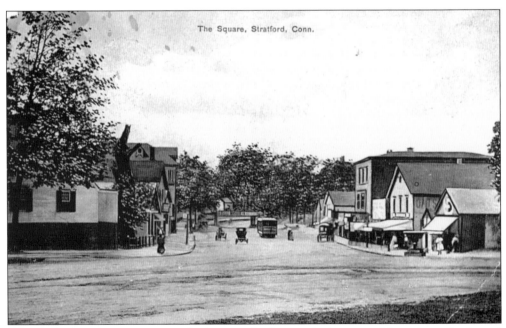

This early view of the town center, looking north, shows a single automobile and a trolley bound for Bridgeport. A watering trough has replaced the ancient flagpole at the intersection. The only brick building is the three-story town hall on the left.

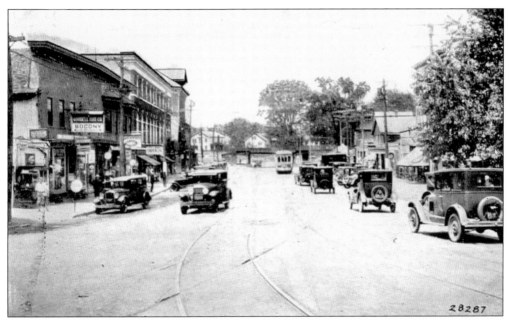

By 1930, automobiles have arrived; gas stations and garages are appearing. In the left foreground, the first Socony sign is displayed, and in the jumble on the right is an early garage. Not visible near the railroad station is an auto agency.

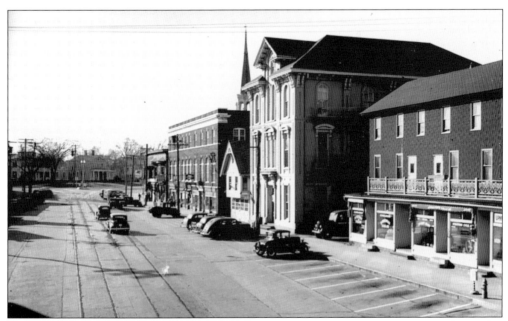

In 1940, automobiles have taken over. Trolleys gave way to buses in 1937, and the tracks are due to be melted into war machinery. Stripes outline the parking spaces.

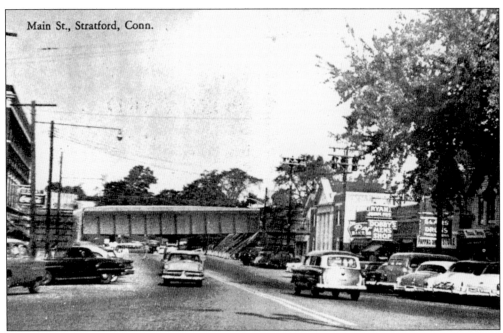

Main St., Stratford, Conn.

In 1955, more change has come to Stratford Center. Where the old town hall had stood, a new turnpike bridge carries Interstate 95 over Main Street, cutting the shopping center in half. Newton Reed's building is gone and other old stores have disappeared. The Stratford Theatre has a new facade, and Dobby has a larger men's shop. There is no evidence that trolleys ever ran this route.

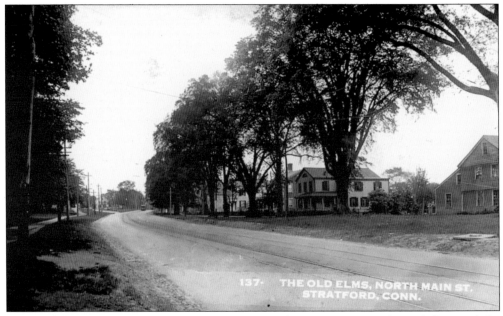

137. THE OLD ELMS, NORTH MAIN ST. STRATFORD, CONN.

North of the railroad viaduct in 1934, concrete-paved Main Street stretches uphill toward the new town hall and between attractive Colonial homes that will soon give way to commercial buildings. The Walker house (on the right), built before 1700, is due to be disassembled and rebuilt on Elm Street.

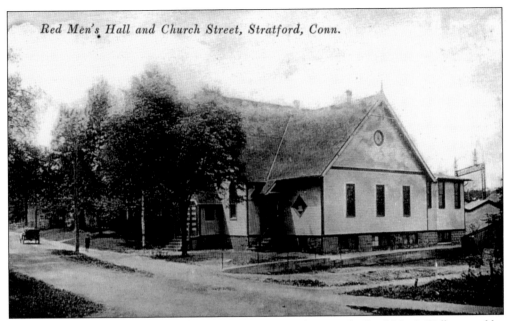

Red Men's Hall and Church Street, Stratford, Conn.

The Neighborhood Church of Christ, on Church Street, became the Red Men's Hall, owned by Okenuck Tribe No. 64. It served as the home of the Polkadot Playhouse until it was dismantled for turnpike construction in the 1950s.

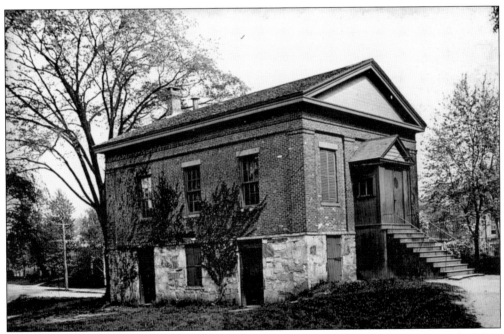

In 1844, the town agreed with the Congregational church to collaborate on a new town building for combined use. In October, the first meeting was held in the new brick building, which was located behind the church. After the town began using the Masonic Temple on Main Street as a town hall, the Mutual Hook and Ladder Company kept its equipment here until 1897. The church continued to maintain it until they tore it down when Packard Hall was built in 1915.

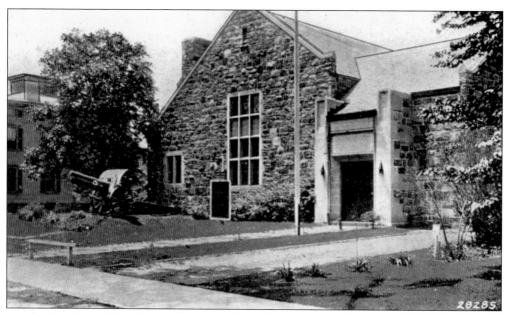

Locals called this building Legion Hall, but when John Sterling left funds in his will to build a civic building, he named it officially Sterling Memorial Hall. As soon as it was completed, it became the home of American Legion Anderson Dunn Kochiss Post 42, and it remained so as long as the post could support it. A World War I German cannon stood on the front lawn until it was melted down in World War II, when it was succeeded by an American 105-millimeter howitzer. When the roster of aging legionnaires grew small, Legion Hall was added to the library, tripling its size.

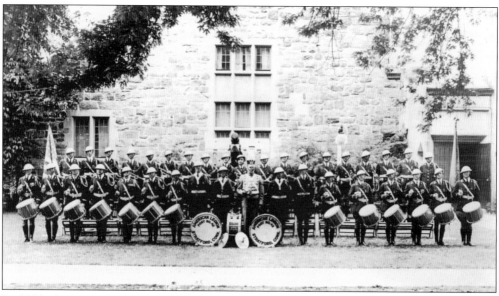

In 1931, American Legion Post 42 founded a 60-man drum and bugle corps. Each year on Memorial Day, the corps led a huge parade down Main Street; its music was heard throughout the town. In the Parade of Champions held each year in different places across the country, the corps took high awards. In 1939, the corps traded the uniforms seen on this postcard for West Point–style costumes, and in 1946 it became the national champion corps.

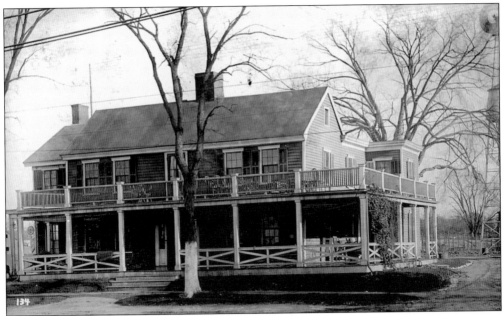

When intercity auto travel grew in popularity in 1910, eateries and gasoline stations sprang up along the highways. The Stratford Inn, on Ferry Boulevard near Washington Bridge, advertised, "Catering exclusively to automobile trade."

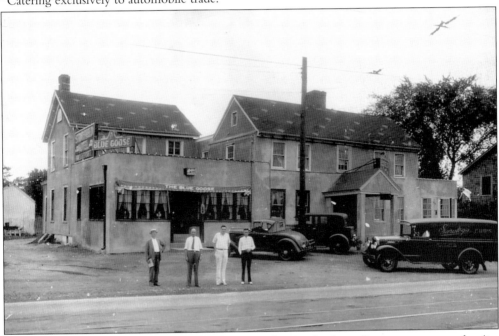

By the 1930s, the Stratford Inn had grown into a thriving business. In a gesture to modernity, its owners, the Moshier family, updated the restaurant and renamed it after a little streamlined train that passed on the railroad every day; they called it the Blue Goose. When the Connecticut Turnpike came through, the state bought the property, and the Moshiers built a new Blue Goose nearby. The Blue Goose, run by the Spadas and later by the Augustyns, still serves seafood near the river.

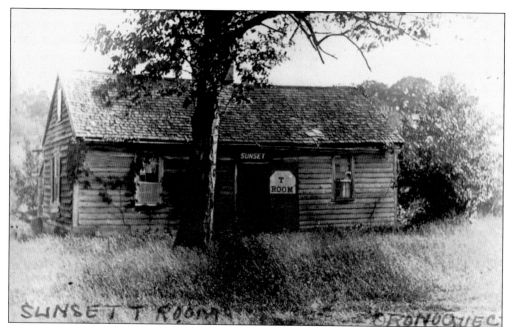

This ancient house, probably built in the 1600s, stood at the foot of Skidmore Hill in Oronoque. Used by early country settlers, it degenerated into a shabby hovel and was lived in by the poorest families. Purchased by Henry Johnson in 1854, it stood unused for years. In the 1920s, when tearooms were in vogue, the cottage was cleaned up and turned into the Sunset Tea Room.

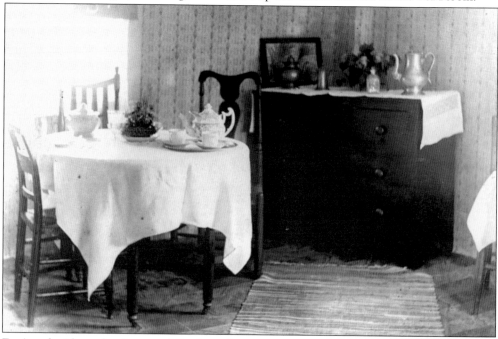

Equipped with outdated rugs and furniture from attics and barns, the Sunset Tea Room opened its door to paying customers. But this was during Prohibition, and tea was no substitute for hard cider, which could be made at home from the product of nearby Cook's Cider Mill. In 1930, the Johnsons tore the building down.

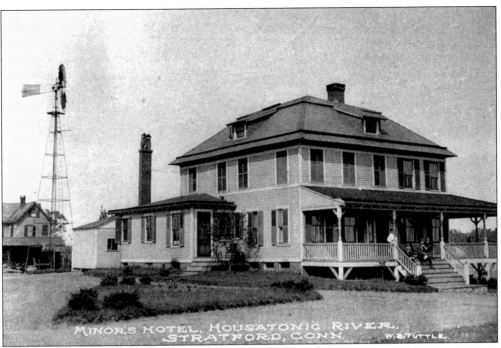

Minor Smith's Shorehouse, located at the river on Housatonic Avenue, was the best place in town for lobster bakes and shore dinners. The Cupheag Club, the Red Men, and the Masons all gathered there for dinners. Before the opening ceremony for the fourth Washington Bridge on March 31, 1894, the dignitaries lunched at Minor's.

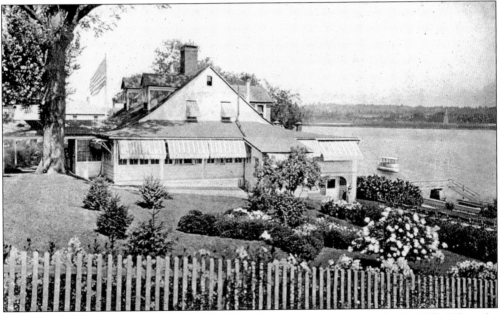

Town dignitaries gathered at the Pinochle Club, located on the river at Peck's Mill. When the River Road was paved in concrete in 1927, the owners opened a catering restaurant; they called it Housatonic Lodge. The lodge hosted weddings and celebratory dinners until it burned in the 1960s.

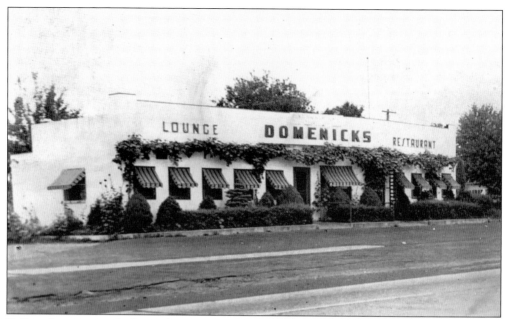

Before pizza was popular in nearly every restaurant, Domenick Spinelli opened his Italian restaurant with pizza as a star attraction, to eat in-house or to go. During World War II, hordes of workers brought into town to work at Vought-Sikorsky gathered at Domenick's every day of the week to savor the spaghetti and the beer.

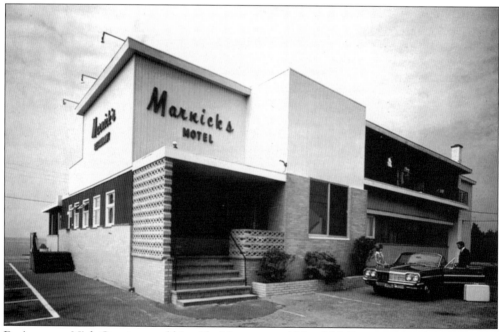

Businessman Nick Quattone and his wife, Mary, opened Marnick's Restaurant and Motel on the site of the Lordship Bathing Pavilion. With several rooms on the beachfront facing Long Island Sound, the motel is popular with tourists. The restaurant, open for breakfast, lunch, and dinner, is patronized by local customers as well.

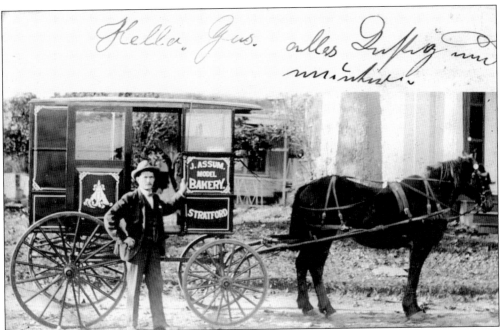

In July 1911, John Assum's bakery and lunchroom opened for business in Stratford Center opposite the New Haven Railroad station. Despite daily sales at the bakery, John still felt it necessary to reach housewives in remote parts of town, so he loaded his wagon with baked goods to deliver to the outskirts. Even though most women were baking their own bread and pies, he had enough customers to make it worthwhile. Home delivery persisted; in the 1930s, Walter Finger was still making home deliveries of Home Pride bread.

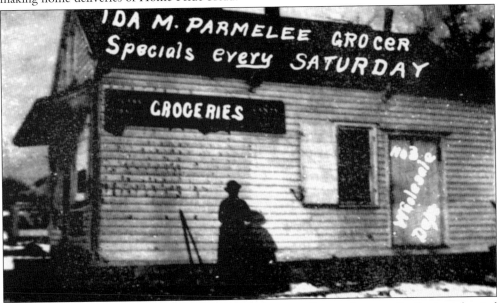

Before Logan Brothers and the A&P chains opened stores, all groceries were family stores located in little wooden buildings. After Thompson's Bakery (at Church Street and Railroad Avenue) closed, Ida Parmelee set up a grocery on the site. It was across from the old railroad station and was an ideally located place for commuters to pick up groceries for dinner.

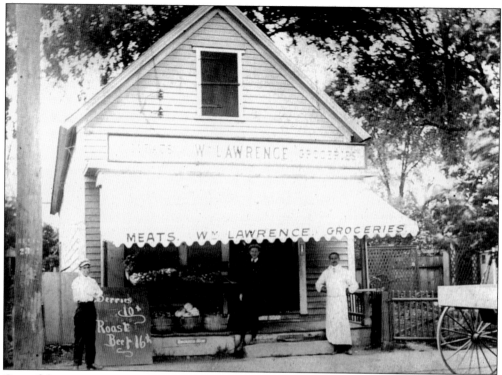

One of the more prosperous grocery stores in town was that of the Lawrence family, where Bill Lawrence was selling roast beef for 16¢ a pound. Housewives could buy their coffee here, and children could purchase penny candy after school. The store was in the heart of town, on Main Street north of Broad Street; it is Dillon's flower shop today.

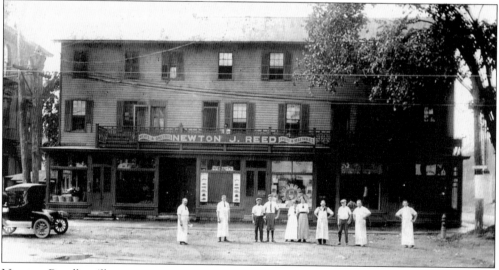

Newton Reed's milk route was prosperous enough that he ventured to set up a large meat and grocery store in Stratford Center in the former Booth building. This photograph shows 10 of the store's clerks. Reed also rented out the upper-floor apartments. In later years, he broke up the store, renting parts to both a butcher and a tailor. The old building, which had once been a hoop skirt factory, came down in the 1950s to make way for the turnpike.

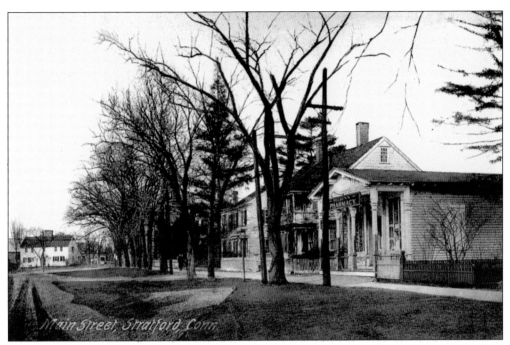

Among the small buildings scattered between old houses is this shop on Main Street south of the town center. In the early 1900s, it was Wilson's Pharmacy (seen above). Later it was the Bon Ton Fish Market (seen below). It has been a library, a post office, a grocery, a drugstore, a fish market, a political headquarters, and a travel agency.

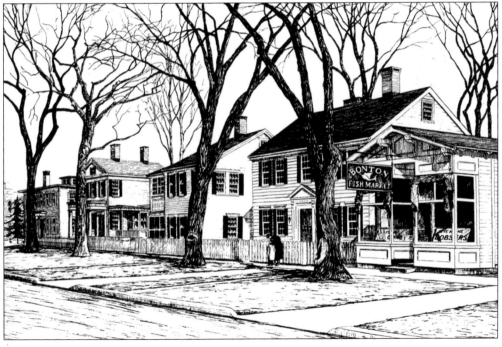

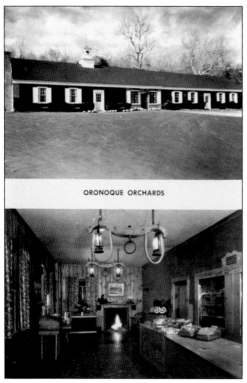

ORONOQUE ORCHARDS

As a project for her alma mater (Mount Holyoke College), Betty Winton decided to bake and sell pies using apples from the Winton orchards. The venture was so successful that husband Hildreth gave up his job on Wall Street and the couple went into business as Oronoque Orchards. Betty's father, a conservative local banker, was opposed to their selling apples until he came by one Sunday after church and saw the crowds. "This isn't so bad, after all," he commented. The business prospered; on the day before Thanksgiving, over 10,000 pies were sold. It lasted until the couple was ready to retire.

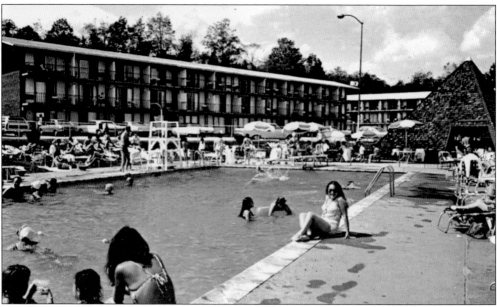

When the new Sikorsky plant and the American Shakespeare Theatre commenced operating in 1955, the Stratford Motor Inn and the Mermaid Tavern opened near the parkway. Later, when the theater faltered and the helicopter business declined, the inn lost business too. The last owner, former U.S. senator and presidential candidate George McGovern, upgraded it to a home for conventions, displays, and meetings, but he finally admitted, "If I'd known then what I know now, I'd have won the elections."

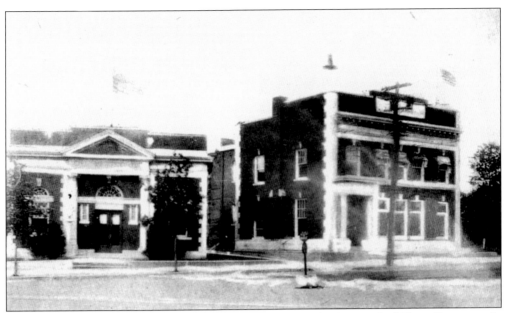

In 1913, Elliott Peck and others formed Stratford's own bank, the Stratford Trust Company. In 1916, the bank built a new brick building in the town center. That same year, the Southern New England Telephone Company, the oldest phone company in the country, built a Stratford office. The phone company is now owned by SBC in Texas.

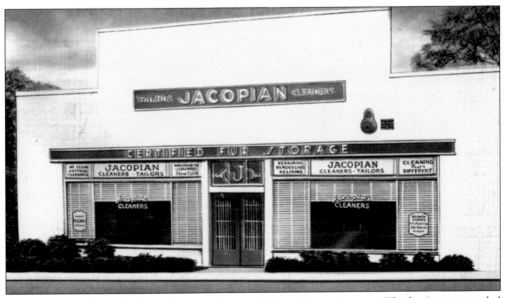

For generations, Jacopian's was the preeminent clothing cleaner in town. The business expanded into clothing repair and alteration, and it later offered fur storage and sold and rented tuxedos. When new cleaning establishments set up shop, business declined and it became time to cease operations.

Dobby's Mens Shop

Happy Holidays

Stratford Center

Merry Christmas

"RECESSION FIGHTER"
30% OFF EVERY ITEM

FROM NOW TILL "92"
SO WHY RUN AROUND???

SAVE ON QUALITY BRAND NAMES
ARROW • VAN HEUSEN • LEVI • HANES
ASHER SLACKS • STANLEY BLACKER
JOHNSON WOOLEN MILLS JACKETS
GATES GLOVES • WEMBLEY TIES
BREMER SLACKS • LORD JEFF

FANTASTIC BARGAINS!

Dobby's Men's Shop, Stratford Center 375-9447

In the Stratford Theatre building, two small shops existed adjacent to the lobby. Irving Dobkin opened a men's clothing store in one of these. After owner Al Pickus restyled the theater, eliminating these areas, Dobkin moved to a much larger building next door. For a generation, Dobby's was the archetypical men's store. Varnished racks and shelves covered the walls. Above the cabinets, a number of Mabel Miller's antiques were on display, lending character to the store. As soon as people entered the store, street noises disappeared. Customers were greeted by name by Dobby or one of his two clerks. The selection of quality clothing was such that there was no need to shop elsewhere. Dobby was Stratford's men's clothier.

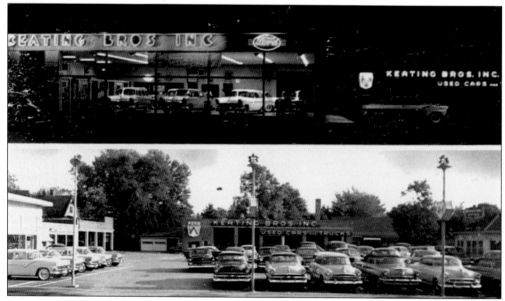

A Keating Brothers advertisement from 1938 boasts the "largest and most complete stock of used cars in Stratford." Under three different owners, Keatings has sold new Fords for 70 years, adding property as the agency has grown. This card shows the showroom and the lot in the mid-1950s.

Two

ON THE SHORE

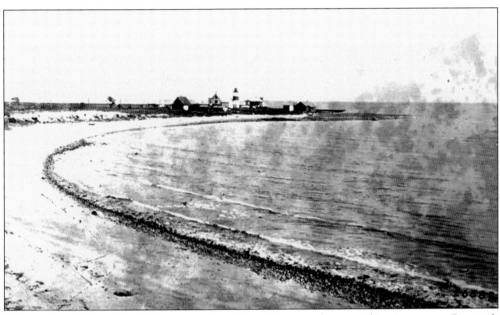

Before the middle of the 20th century, Lordship Point was barren. This view across Bennett's Cove shows the lighthouse station as it was *c.* 1915, with the 1882 light tower and keeper's cottage, the 1911 sound apparatus, and outbuildings. Above the empty 40-foot-high bluffs was an abandoned flying field, and there were pocks and craters in the brush where generations of men had dug for Captain Kidd's purported treasure without success.

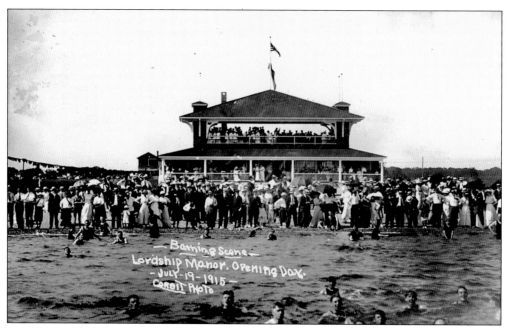

On July 15, 1915, the pavilion at the Lordship Manor beachfront opened for business. Crowds of visitors from Bridgeport and Stratford, brought by trolley car and motorcar, lined the beach, and scores of swimmers enjoyed the clear waters of the sound. With a pavilion, a casino, and a golf course, the beach resort became a popular summer destination.

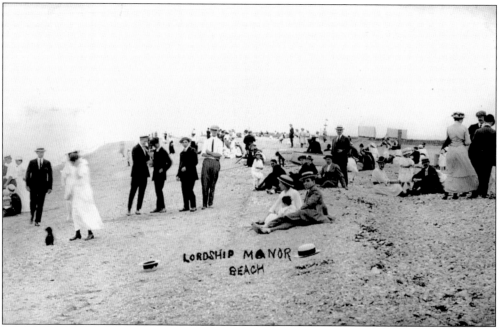

On opening day in 1915, more people came to Lordship Manor to watch than to swim, although they wore hardly any more clothing than the overdressed bathers of the time would have.

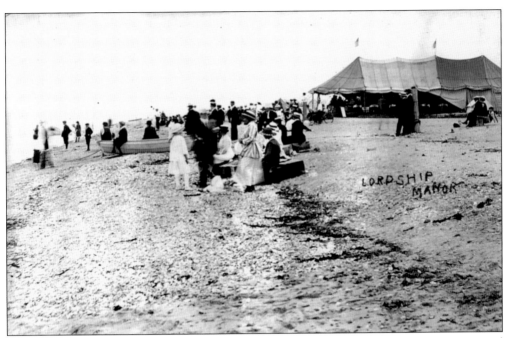

The crowds at Lordship Manor on opening day were so large that tents and awnings were erected as places to serve shore dinners and refreshments. Straw hats were summer wear for both men and women.

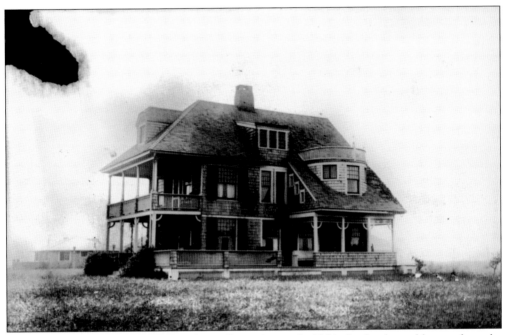

After Lordship Manor was chartered by William Hopson in 1896, the first lots sold were along the shore. Large Shingle-style homes were built, some with their own wells and windmills. Telephone service was through the lighthouse; electricity came later.

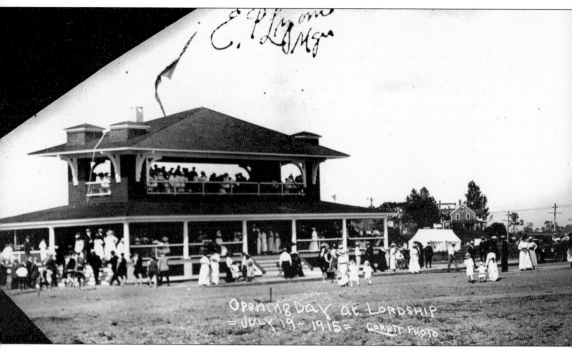

This photograph of opening day at Lordship Manor shows E. W. Wilson's office east of the

In 1911, Lordship Manor was sold to developer Wilkenda. This is a view of Wilkenda's main office and stables in 1915. The office later served as the clubhouse at the golf club and then

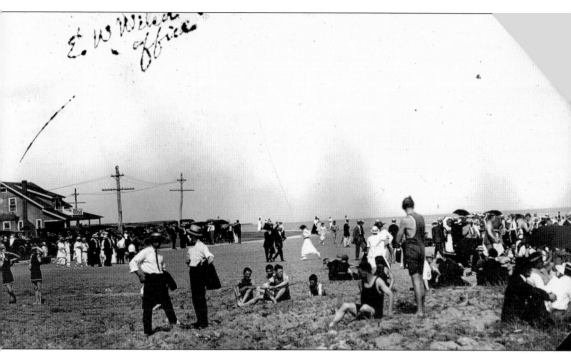

pavilion. That building served as Pop's Restaurant for many years and is still used as a restaurant.

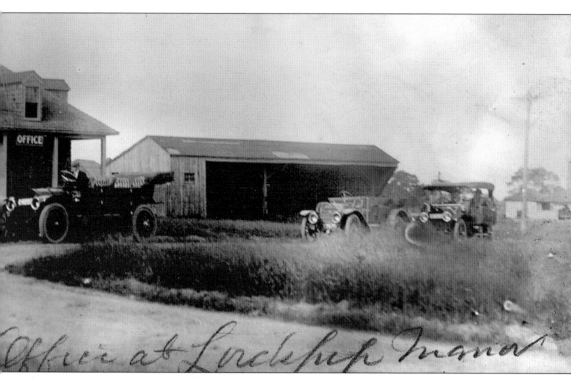

became a private home. It is still there.

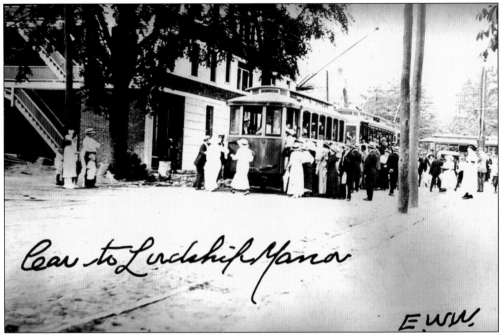

To get to Lordship Manor in 1915, trolley patrons took Connecticut Company cars to Stratford and Hollister Avenues in Bridgeport and then transferred to little Lordship Railway Company cars for a ride across the salt meadows to the beach.

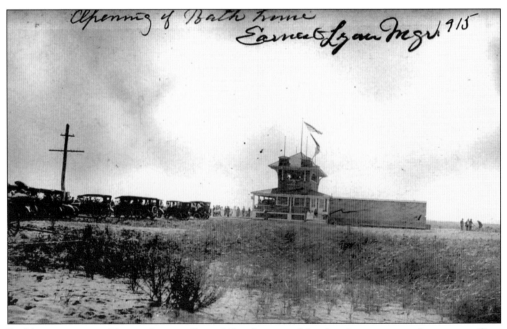

Bathhouse manager Earnest Lyon collected fees for use of the dressing rooms at the new pavilion in 1915. The open upper deck was crowded by sightseers enjoying the view across the sound.

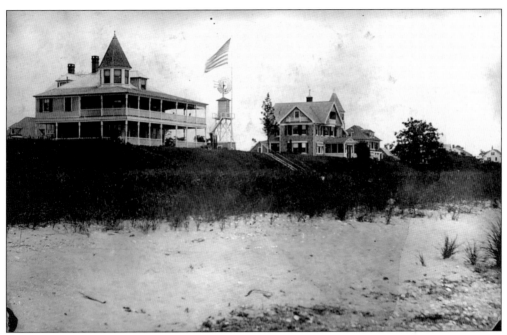

Two of the first large houses built by the Lordship Park Association at the turn of the century shared a windmill and a well. Perched high up on the bank, these two have outlasted hurricanes to this day.

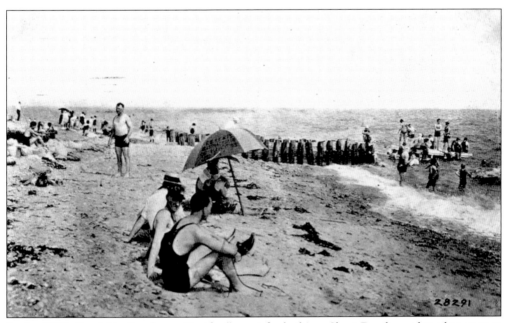

In the 1920s, Lordship Beach was Stratford's spot for bathing. Short Beach was leased to cottage owners, and Long Beach was not developed. But Lordship Beach was washed away by the 1938 hurricane.

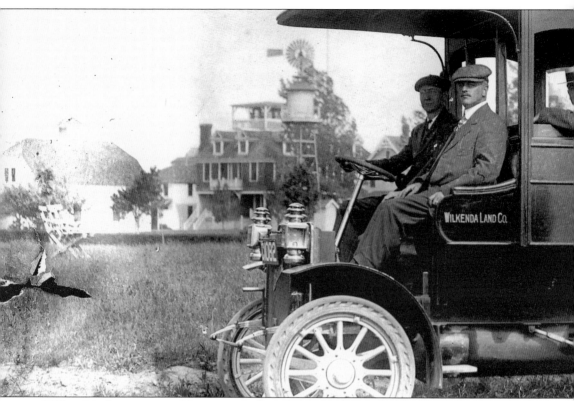

Wilkenda's jitney was multipurpose. Before the trolley line opened in 1915, it transported beachgoers from Bridgeport. It was also useful for showing potential buyers around and for

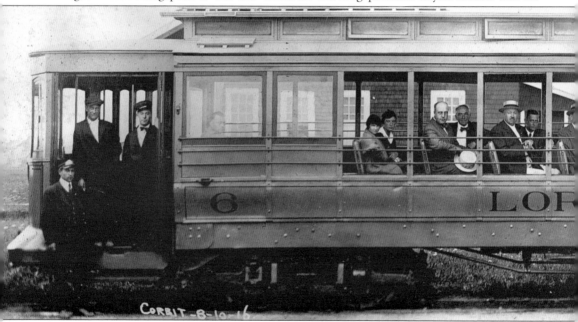

When a projected Bridgeport-Danbury interurban line went bust, the Lordship Railway Company snatched up a large car. But they were never able to fill it, and soon the little trolley line tore up its

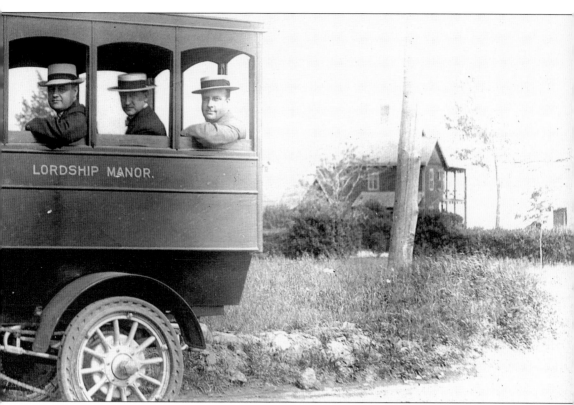

gathering businessmen and property owners for meetings.

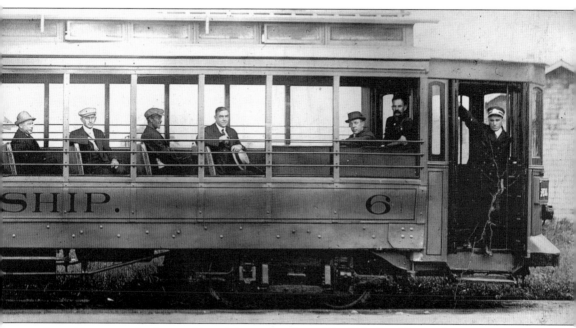

tracks and began running buses, although it continued to call itself the Lordship Railway Company. The other half of the trolley line, which would have traveled up Main Street, was never built.

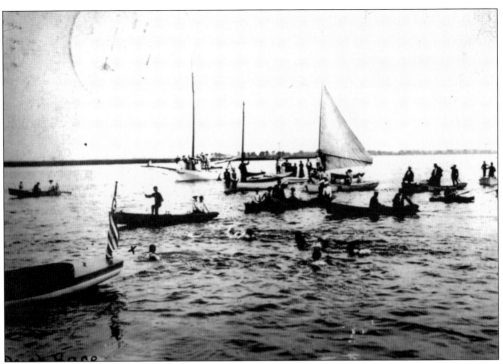

Labeled "Duck Race," this postcard depicts a water event taking place off Short Beach in the early 1900s, a time when the waters were much cleaner than they are today. Sailors and rowers have shown up to watch.

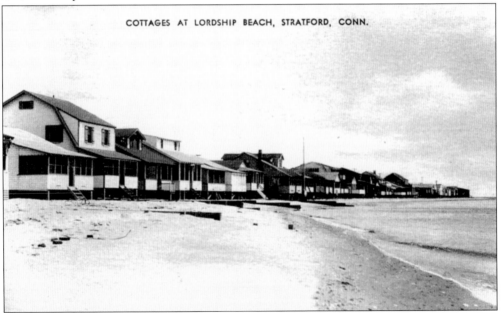

COTTAGES AT LORDSHIP BEACH, STRATFORD, CONN.

The town leased space west of the pavilion for summer cottages. Built on pilings at the shore, the flimsy shacks were often sacrificed to hurricanes, whose waves lifted them off their foundations and whose currents washed away the sand. Surprisingly, many of the cottages remain. This photograph was taken before the 1958 storm.

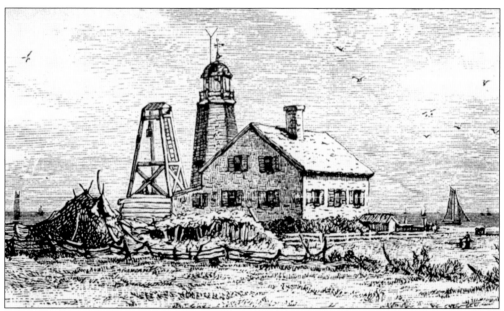

Stratford Point projects two miles out into Long Island Sound. Its lighthouse was built in 1822. In this view from 1874, a bell tower has been added to warn off storm-tossed ships. Rufus Buddington, the light keeper, lived with his family in the keeper's cottage; he had eight children.

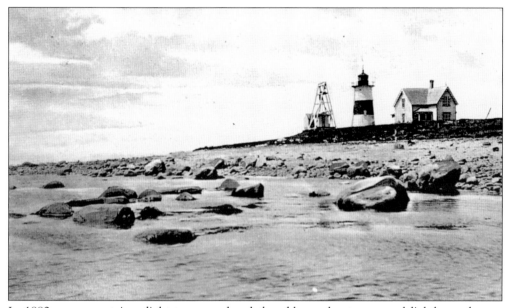

In 1882, a new cast-iron light tower replaced the old wooden tower, and lighthouse keeper Theodore Judson's family moved into a new cottage.

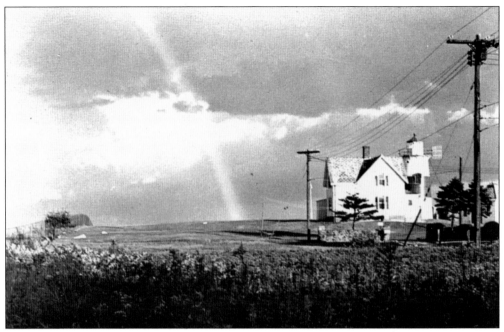

A rainbow appears, the storm is over, and all is well.

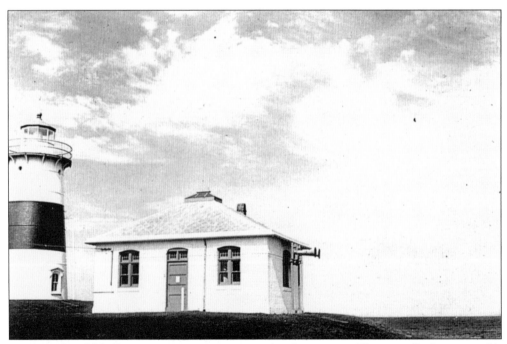

In 1911, the old bell tower gave way to a new signal apparatus. The two diaphones on this building are powered by air from a diesel or electric compressor. They were audible halfway across the sound.

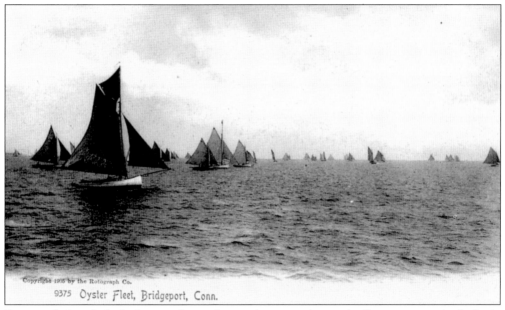

Copyright 1905 by the Rotograph Co.

9375 Oyster Fleet, Bridgeport, Conn.

State regulations forbade the use of powerboats when oystering, so the fleet was comprised of only sailboats before the 1950s. Here the whole fleet is working the grounds off Stratford. Captain Bill Lewis (in the foreground) converted his sandbagger by reducing the size of his working mainsail and adding a topsail so he would be the first to the buy boat in the harbor.

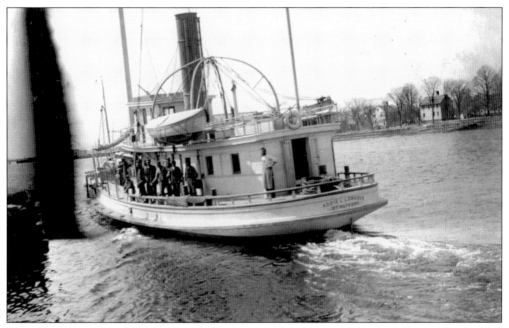

Steamboats were added to the oyster fleet to spread culch (oyster shells) on the beds, take the crop from the sailboats, kill marauding starfish, and set boundary stakes. The *Addie L. Lowndes* was built in 1908 and often worked out of Stratford for the Lowndes Oyster Company.

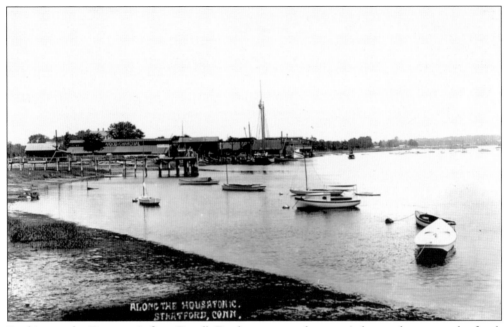

Looking up the Housatonic from Bond's Dock, we see a schooner tied up at the upper wharf and, beyond, the Pootatuck Yacht Club, formerly the Lewis Oyster Company.

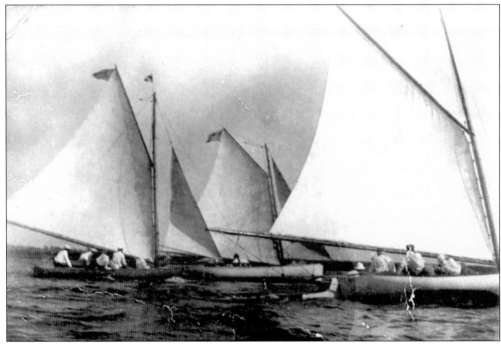

Labeled "A Race on the River," this postcard shows a group of overrigged cats and sloops with good-sized crews (mostly for ballast) in a highly contested race. The boats belong to members of the Housatonic Boat Club.

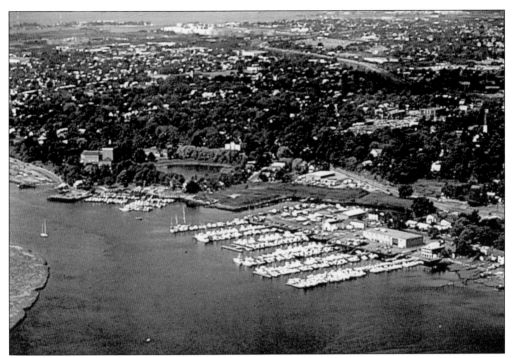

As early as the 17th century, Shipyard Point, where Ferry Creek meets the Housatonic River, was home to shipyards with many owners. Beach's, Curtiss's, Wheeler's, Russell's, White's, and Bedell's Yards, in turn, gave way to Brewer's Marina, located at the end of Broad Street at the upper wharf. Seen from the air, the American Shakespeare Theatre, the Housatonic Boat Club, and Brown's Boat Works are on the left; Pootatuck Yacht Club is at the right.

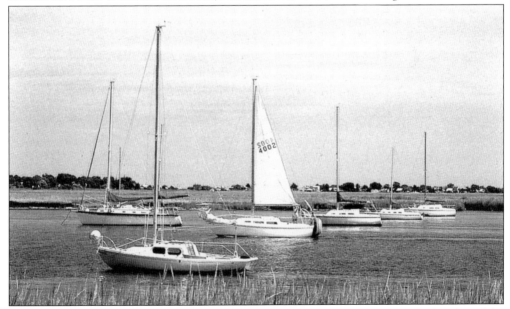

Seen from the Stratford side, the Housatonic Boat Club fleet is moored on both sides of the channel; the marsh beyond the river is the Charles E. Wheeler Wildlife Management Area. The Milford shoreline is in the distance.

The reverse side of this 1908 postcard of Bond's clubhouse tells a sad story of the drowning of two children in the river.

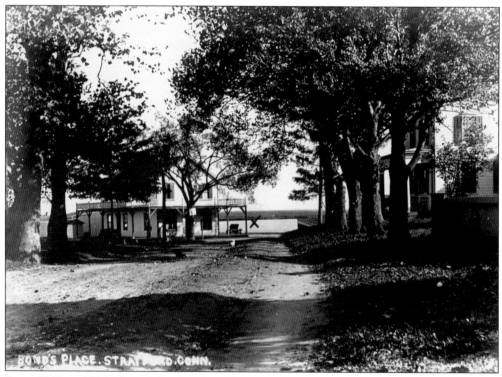

From 1883 to 1916, Capt. John Bond ran his prizefighter training camp at the old steamboat wharf now known as Bond's Dock. Here many of the world's top boxers spent the summers exercising, jogging, and sparring in the ring, preparing for championship fights.

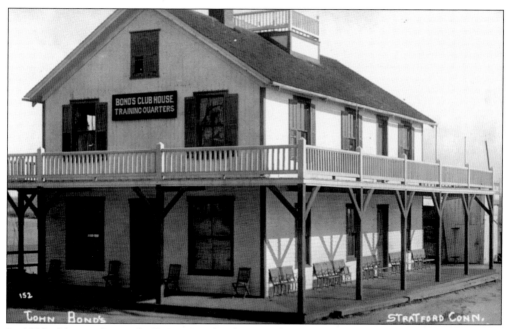

In 1883, this warehouse, built in 1824 for the steamboat trade, was converted into the training camp by Captain Bond, an oysterman from Long Island. Until his death in 1916, Bond operated the camp and ran a saloon and a grocery store, while his brother Ashbel built oyster boats on the dock.

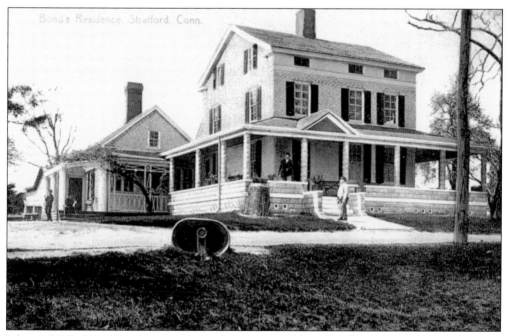

John and Julia Bond lived across the road from the clubhouse and boarded fighters in training. Captain Bond is standing at the front steps of his house.

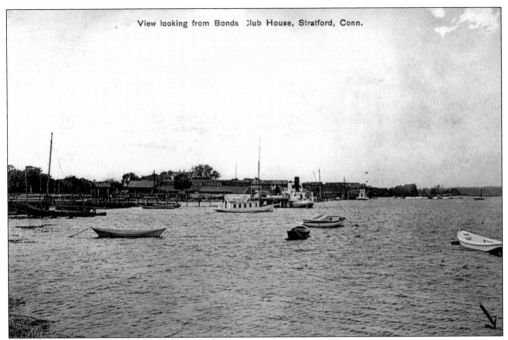

Upriver from Bond's Dock, the riverfront is laced with oyster-boat moorings in 1910. While the boats are out working on the sound, their skiffs are left at the moorings. In the background is a cabin sloop, and beyond that, Bedell Benjamin's steam yacht is tied up at his private dock.

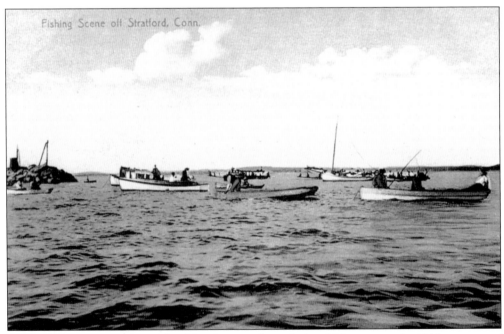

Fishing Scene off Stratford, Conn.

A hundred years ago, the mouth of the river was busy during fishing season. In 1910, a group of fishing boats anchored at the end of the breakwater (which is still under construction) fishes for stripers, blues, or tautog (blackfish)—whatever is running.

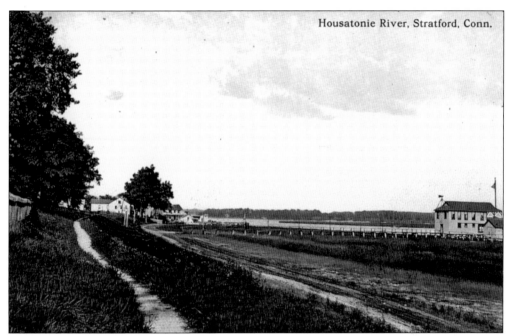

The Housatonic Boat Club is the oldest remaining yacht club in the state. When it was young in 1890, its property was all marshland, and the shore road was a private way past the club. A boardwalk stretched across the marsh on pilings to reach the club.

HOUSATONIC RIVER. STRATFORD. CONN.

The lawn at Housatonic Lodge stretched to the river and was ideal for outdoor steak roasts and shore dinners. Across the river, Milford is as yet undeveloped; only the Naugatuck Railroad lines the shore, and new transmission towers mark the crossing.

From the Stratford side of the Housatonic, where the trolley line to Shelton skirted the shore of the river, a view upriver was unobstructed by any manmade object. The same view today shows the Merritt Parkway bridge and includes a gas tank on the Tennessee natural gas pipeline.

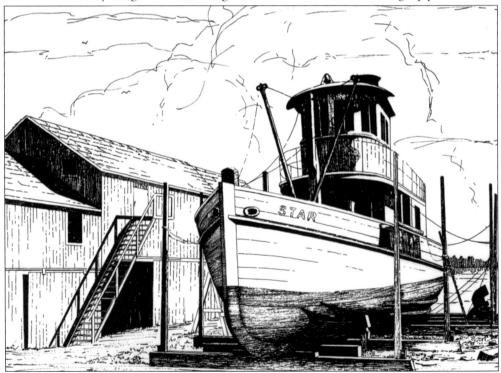

The Radel Company's oyster steamer *Star* was built in New Haven in 1900, but most of her maintenance and overhaul was done at Bill Bedell's yard in Stratford. This sketch by Frank Campbell shows the *Star* ready to be recaulked and painted *c.* 1930.

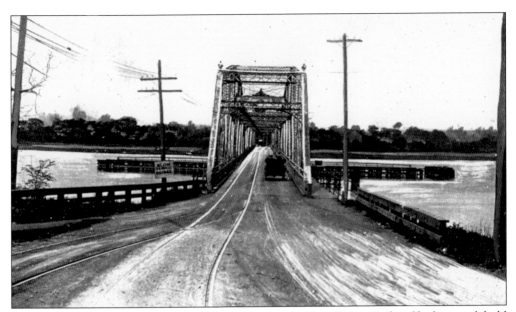

When the fourth Washington Bridge went up in 1894, the New Haven Railroad had a stranglehold on the state legislature, so the road width was limited to 17 feet to prevent the building of a trolley line to compete with the railroad. Later, the railroad owned all the trolley lines, so they allowed a track across the bridge. But the existing road width limited the project to one track plus one lane of vehicle traffic.

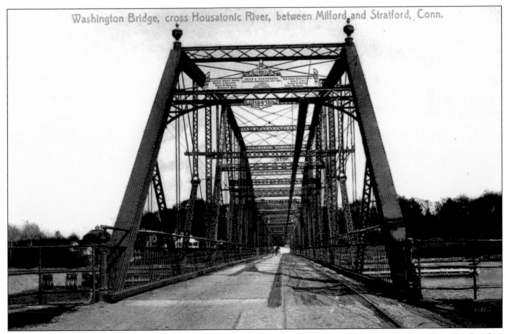

This view shows the fourth Washington Bridge from the Milford side. Built in 1894, the bridge became totally inadequate when automobile traffic inundated the Post Road. After only 27 years of use, the bridge was replaced in 1921 by a modern wide bridge, and the highway was designated U.S. Route 1.

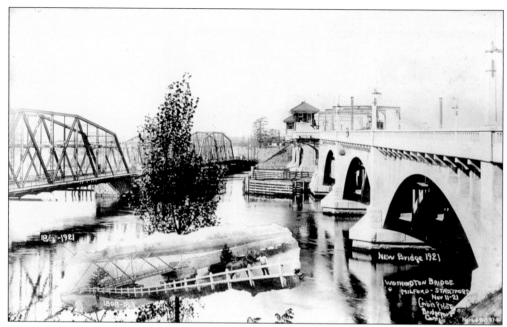

This collage shows all of the Washington Bridges together. In the foreground is the first bridge, built in 1803 and soon washed out by ice, then rebuilt each spring as needed. On the left is the iron-girder fourth bridge. On the right, the new fifth bridge, a lift bridge, spans the river.

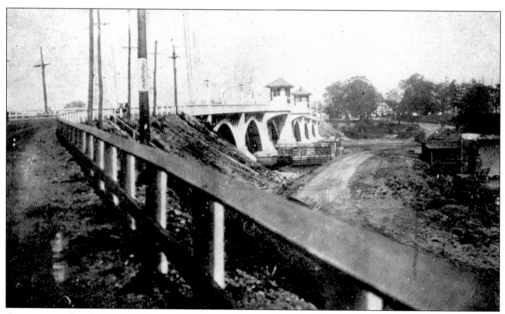

As soon as the fifth Washington Bridge was operating in 1921, the old bridge was removed. In this view from the Stratford side, the road leading to the old abutments remains, together with the shanty on the Stratford side where refreshments were sold.

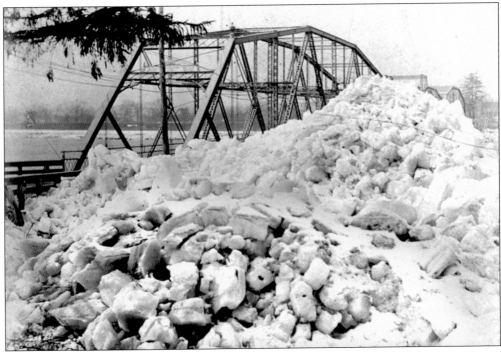

The year 1904 was a frigid one. When the spring thaw arrived in March of that year, cakes of ice jammed above the bridge and broke into lumps that lasted for months. This view is from the Milford side.

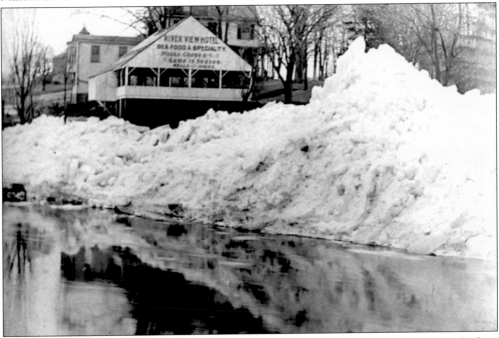

Along the Milford riverbank in the spring of 1904, crunched-up ice created jams as high as 15 feet. Where the highway turned north from the bridge and went up the hill to the River View Hotel, the vacant dining porch came close to being washed away.

Until the 20th century, when Lordship was known as Great Neck and was divided from the town by the creek and the marsh, the only road to Great Neck was an extension of Main Street to the south, past the Old Field, where colonists planted crops, and over Neck Creek Bridge.

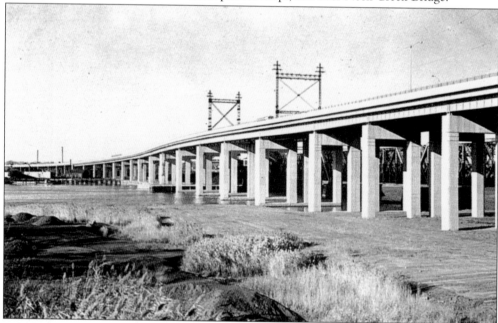

When the Connecticut Turnpike opened in 1958, a new bridge appeared across the Housatonic. Named for the governor, the road became the John Davis Lodge Highway, Interstate 95, but the bridge had no name. Inspired Stratford Historical Society members made a recommendation, and the bridge became the Moses Wheeler Bridge, named for the ferryman who was first to carry travelers across the river. Now, half a century later, the bridge will be expanded.

Three

WHERE WE LIVE

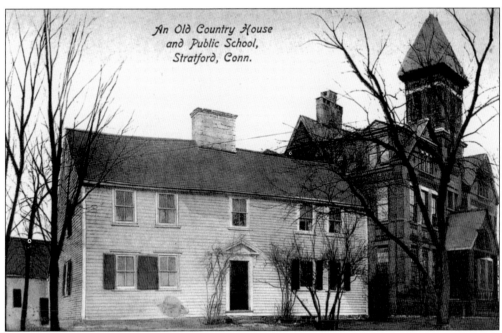

As commercial buildings filled 20th-century Stratford Center, the Dayton homestead remained, located between a new grain store and the Consolidated School. It became a tearoom; then, in 1913, the newly formed Stratford Trust Company chose it for its office site. Three years later, the bankers replaced the house with a brick building, complete with vault and lobby.

In 1753, U.S. postmaster Ben Franklin traveled the Boston Post Road with a group of assistants to measure distances and place milestones by the roadside. Stratford received five of the markers. This stone, which reads, "14 miles to N H," still stands not far from the river, where East Broadway meets Ferry Boulevard.

A plaque placed at the junction of East Broadway and Elm Street 100 years ago memorializes one of several Post Road routes through town. This corner is now several blocks from U.S. Route 1 and Interstate 95.

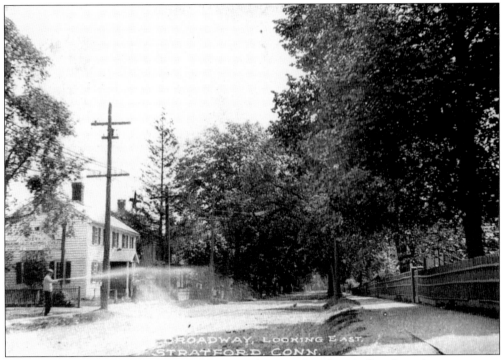

In 1916, the traction company made plans to add a second track to its line from the town center to the bridge. Because East Broadway was narrow, alternate plans were to lay the eastbound track on Judson Place or to build a private right-of-way through the marsh. Despite the width of the road, the new track was laid alongside the old one, and in 1921 it was extended across the new bridge to Milford.

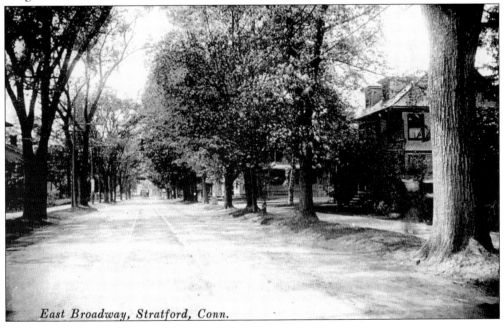

East Broadway, Stratford, Conn.

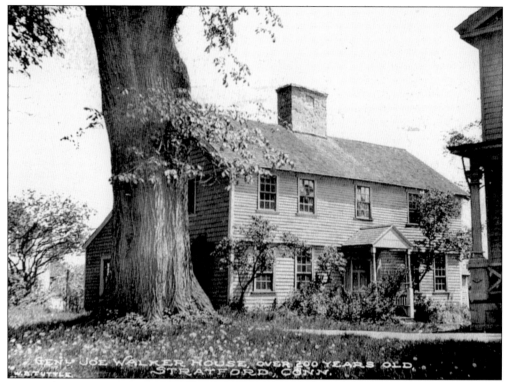

For nearly 250 years, the ancient General Walker house stood facing south on Main Street, shaded by the largest elm in town. In 1934, a new house took over the site, and Sterling Bunnell moved the old house to Elm Street, where it began a new life among other remaining pre-Revolutionary homes.

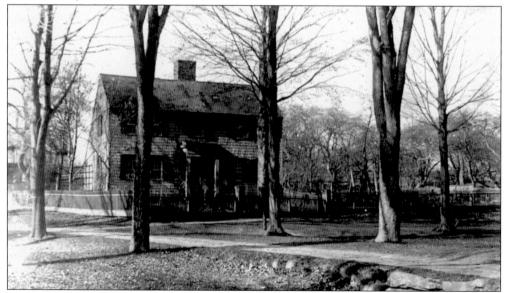

Where the road to Nichols Farms began, a neighborhood of Booth families settled. The Booth house at the corner of Nichols Avenue and Booth Street serves as a flower shop today. The old beech tree in the yard remains to shade the house.

In 1899, Stiles Judson opened a new street on his land between Main and Elm Streets and sold the building lots. East of Elm Street, Parrott Street became part of Judson Place. This view looking west shows new houses built on the street.

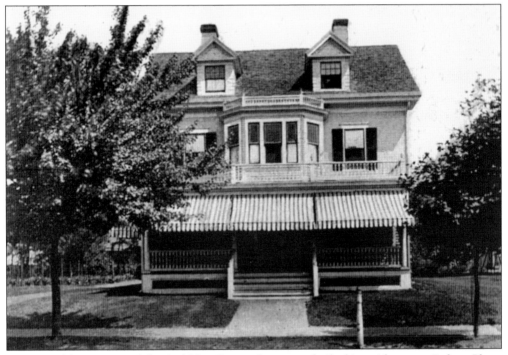

Starr Beardsley, owner of the Sealshipt Oyster Company, built this residence on Judson Place. Beardsley owned the oyster steamer *Stratford*. The trolley line never built its track on Judson Place because the project was contested by the residents.

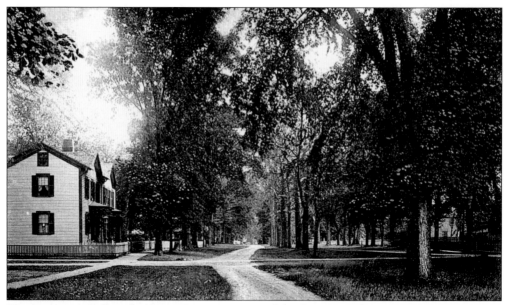

Elm Street, originally called Front Street, was one of the few streets that remained 20 rods wide. The parklike common that resulted gave welcome to the grandest 19th-century mansions in the town. The north end of Elm Street was built up later and added to a fine neighborhood.

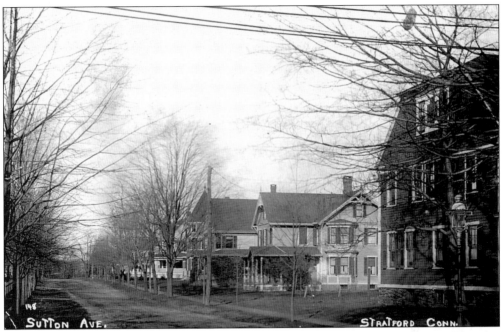

The Sutton Avenue and Harris Street (Broadbridge Avenue) areas, built up in the post-Victorian period, were filled with Stick-style houses, simply trimmed. Before the advent of air conditioning and comfortable closed automobiles, front porches were the usual summer sitting spots.

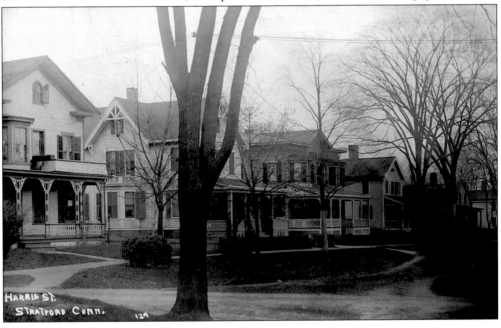

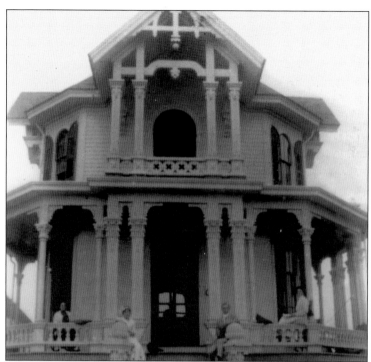

The most elegant cottage on the Lordship shore was made by adding rooms to the east wing of P. T. Barnum's palatial Waldemere, which was brought from Bridgeport by barge.

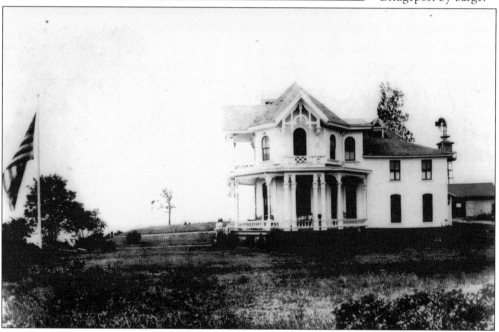

The first New Haven Railroad station was located on Linden Avenue, west of Church Street. North of the crossing, King Street continued across Broadbridge and up a modest hill to Barnum. Here, just a few steps from the depot, was an ideal place for a businessman to live. The morning train brought goods and produce from New York, and a visit to Bridgeport was 10 minutes away.

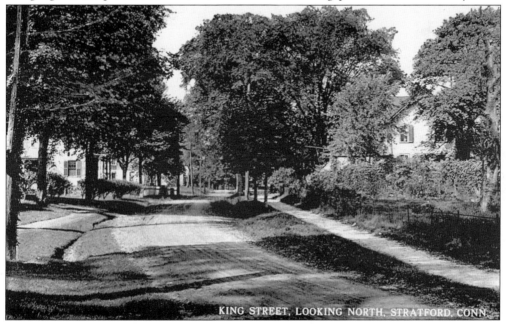

KING STREET, LOOKING NORTH, STRATFORD, CONN.

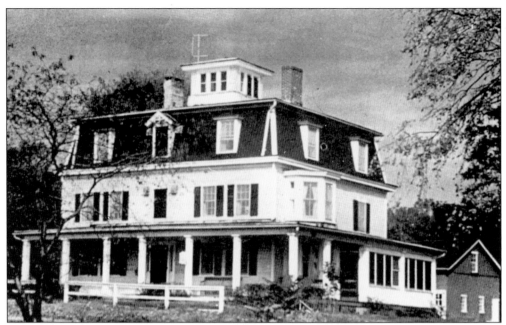

The house at Mack's Harbor led many lives. Built *c.* 1742 as a large saltbox, it was converted to a two-story colonial, then to a mansard-roofed Italianate. In 1932, it became an inn, Beach's Manor on the Housatonic. In 1955, it was converted to the Captain's Walk. Today it is again a private home, with 15 rooms and a cupola.

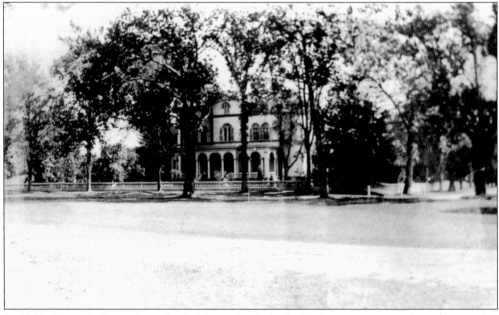

In 1862, New York merchant Frederick Benjamin built this brownstone mansion, the grandest house in Stratford, tearing down or moving other houses on the estate in the process. Son Arthur Bedell Benjamin and his wife, Jessie, spent their adult lives lounging on the porch or traveling the New England waters on their steam yacht *Continental*. The house is still on West Broad Street as a rental apartment house.

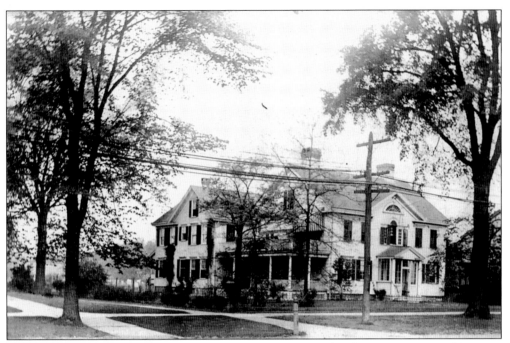

The McEwen house, on Main Street, is an outstanding example of 1797 Georgian architecture. Located between the library and the Sterling house, it has been owned by Sterling descendants for more than 100 years.

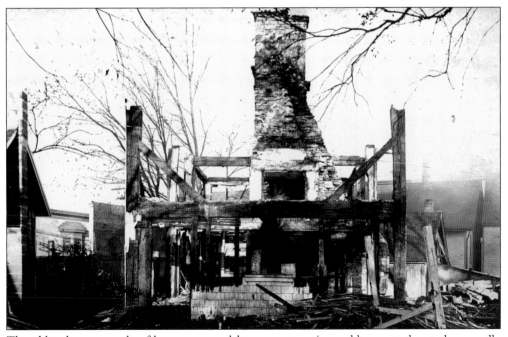

The oldest houses, made of heavy post-and-beam construction, seldom rotted out; they usually succumbed to fire. The James Clark house dated from 1670.

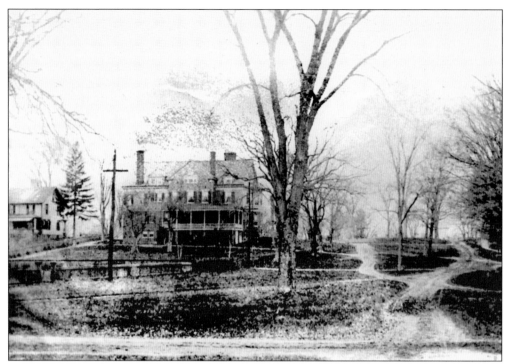

Walter Wheeler's home on Academy Hill was large enough to operate as a boys' school in the 1920s, first as Mount Carmel School for Boys and then as Johnson Academy. After Wheeler died and the school closed, the house was torn down to save on taxes.

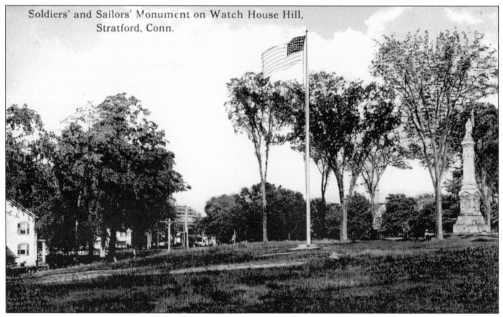

Soldiers' and Sailors' Monument on Watch House Hill, Stratford, Conn.

Since the Soldiers and Sailors Monument was erected in 1889, Academy Hill has sometimes been labeled Monument Hill. Several new memorials have since been added to the site. A granite memorial to the men and women who served in World War II was dedicated on Memorial Day in 2004.

Four

EDUCATION
AND WORSHIP

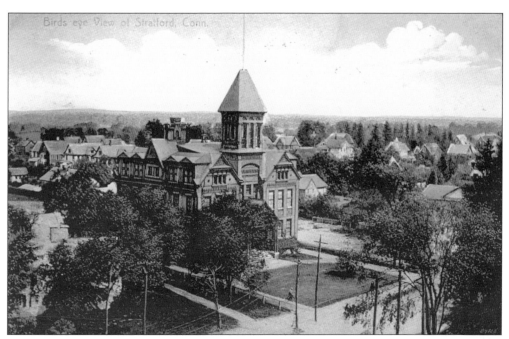

In 1885, the Consolidated School took the place of several one-room schoolhouses that were scattered around town. This photograph, taken from the steeple of the Congregational church, shows the school surrounded by new 20th-century houses, which augmented a neighborhood of pre-Revolutionary homes.

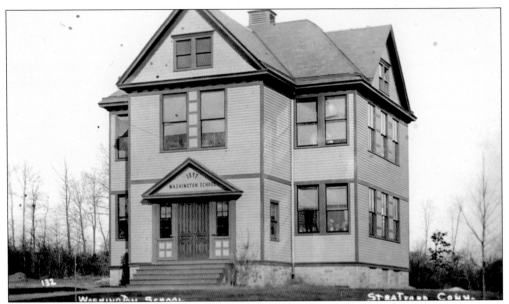

In 1897, the eight-room Consolidated School was already suffering growing pains, so another new school went up. Washington School was built on North Avenue, south of Paradise Green. It had four rooms, and there was an outdoor lavatory building in the rear yard.

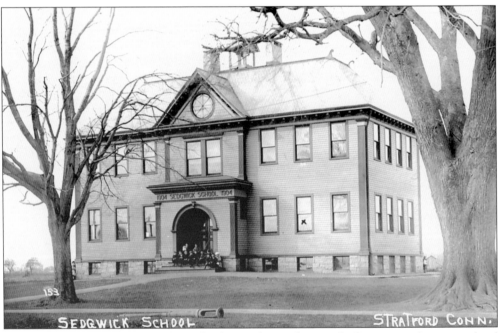

When immigrants began raising large families in the southern end of town, another new school was necessary. In 1904, Sedgewick School, named for retired professor Frederick Sedgewick of the Stratford Academy, was built.

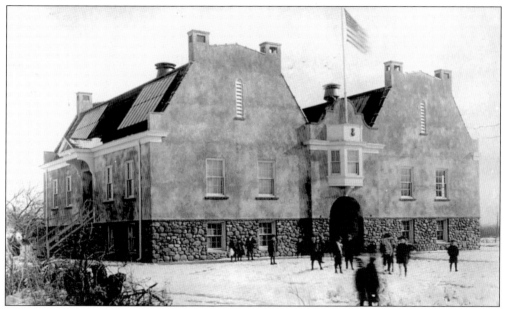

In 1913, superintendent of schools William Kelsey named the new Huntington Road school for inventor Eli Whitney. The school was acclaimed as modern and well lighted, with skylights in every room, but it closed in midwinter because it was too difficult to heat.

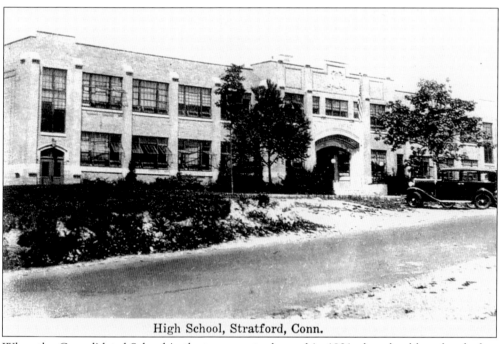

High School, Stratford, Conn.

When the Consolidated School in the town center burned in 1921, the school board rushed to find spots for classes all over town. Church halls, civic clubs, stores, and the theater were pressed into service. Stratford architect Wellington Walker began the urgent task of designing a new high school but turned the job over to another firm when he was told to cut corners. The new 10-room Stratford High School opened for business in the fall of 1925.

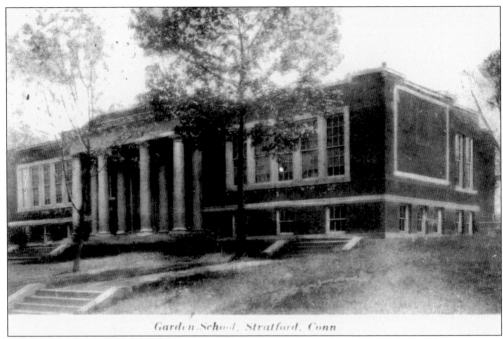

Garden School, Stratford, Conn.

When population growth in the north end overloaded Washington School, an eight-room brick school was planned; the question was where to locate it. The compromise was to build two four-room schools, and in 1914, Garden School and Nichols School went up. Both had second floors added later and were then expanded further.

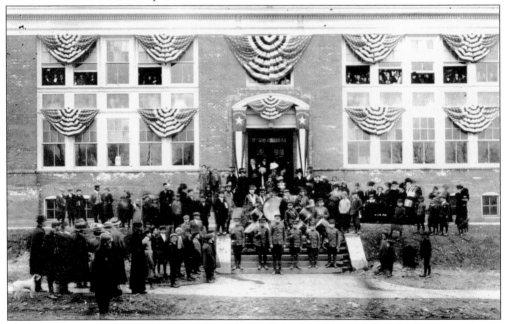

As the Barnum Avenue trolley line was being built, factory workers and their families were already swarming from Bridgeport into Hollister Heights. Here, superintendent of schools William Kelsey leads the Stratford Schools Band at the 1910 dedication of Franklin School, the town's first two-story brick school. The school has been expanded several times since then.

In 1722, Dr. Samuel Johnson became the first rector of the first parish of the Church of England in Connecticut, and on Christmas day in 1724, the first church building was opened. In 1754, he became the first president of King's College in New York, now Columbia University.

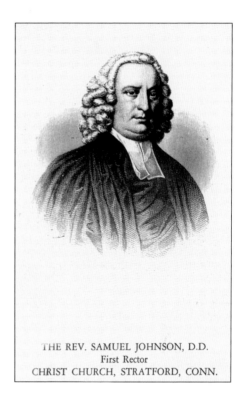

THE REV. SAMUEL JOHNSON, D.D.
First Rector
CHRIST CHURCH, STRATFORD, CONN.

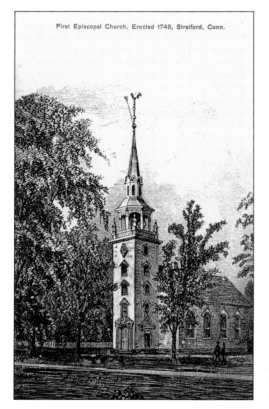

First Episcopal Church, Erected 1748, Stratford, Conn.

The second Church of England building, completed in 1745, stood on Main Street, directly north of the present church. The steeple was 120 feet high and was topped by the same rooster weathervane still used on the present church. The church was used until 1858.

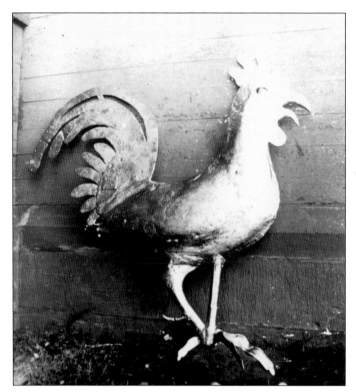

This weathercock has stood on two Episcopal churches since 1743, when it was made by Col. John Benjamin, a goldsmith and member of the church. Soldiers of Col. Simon Frasier's Highland Regiment used it for target practice when they were encamped on Watch House Hill (now Academy Hill) in 1758. The rooster has been repaired; it has no holes in it today.

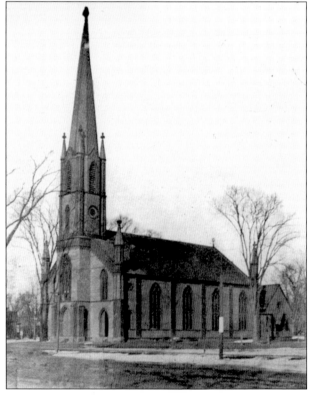

In 1858, the present Christ Episcopal Church was built according to the design of architect Henry Dudley. The church was in the American Gothic style and was painted in earth tones, which were popular in that period. Note the earlier church, which has been moved behind the new one.

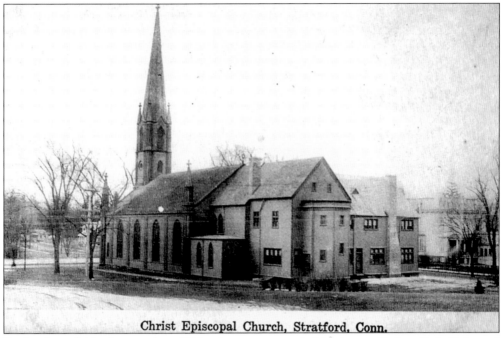

Christ Episcopal Church, Stratford, Conn.

By the time of this photograph, *c.* 1910, a large two-story hall has been added to Christ Episcopal Church, and an addition has been made to the hall. The small corner turrets, part of Dudley's design for the main building, have not yet been removed.

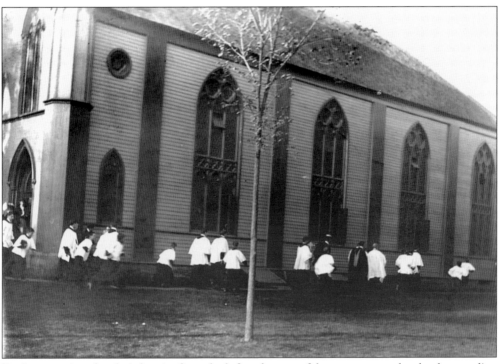

During a service, the choir hurries from the loft at the rear of the sanctuary to the altar by traveling outside. The building is still painted in its natural colors in this photograph.

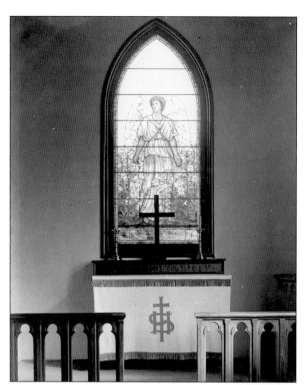

The chapel in Christ Episcopal Church contains a window dedicated to the memory of Mrs. Edward Allen.

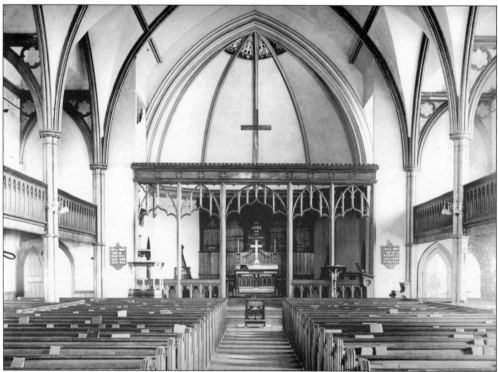

The Gothic wooden interior of Christ Episcopal Church remains essentially as it was built in 1858.

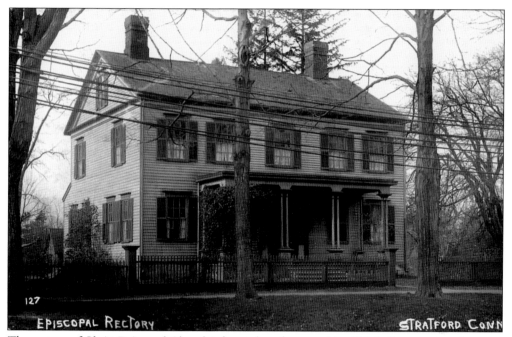

EPISCOPAL RECTORY STRATFORD CONN

127

The rectory of Christ Episcopal Church is located on the west side of Main Street, across the street from the church building.

The present St. James Roman Catholic Church is seen here as it looked when it was constructed. The cornerstone was laid on July 13, 1913. Some 10,000 people were in attendance, arriving in scores of trolley cars. The church was dedicated on May 17, 1914. The building is of gray tapestry brick, trimmed with Indiana limestone. The church seats 600.

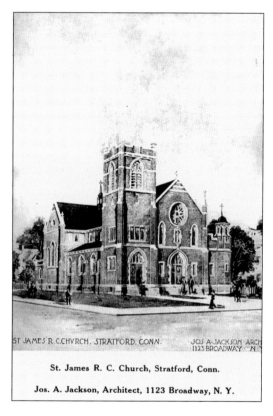

ST JAMES R C CHVRCH. STRATFORD. CONN. JOS·A·JACKSON·ARCH
1123 BROADWAY· N

St. James R. C. Church, Stratford, Conn.

Jos. A. Jackson, Architect, 1123 Broadway, N. Y.

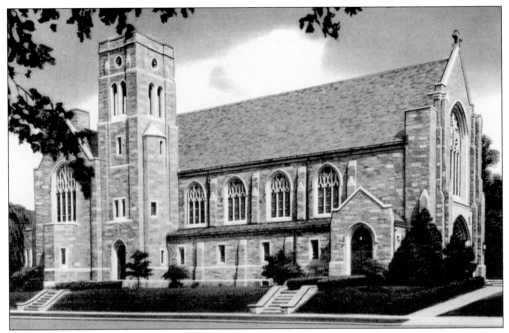

Because the Slovak residents of Hollister Heights wanted to worship in their mother tongue, they formed Holy Name of Jesus Roman Catholic Church. On December 16, 1923, this new church building opened at the intersection of Barnum and Boston Avenues.

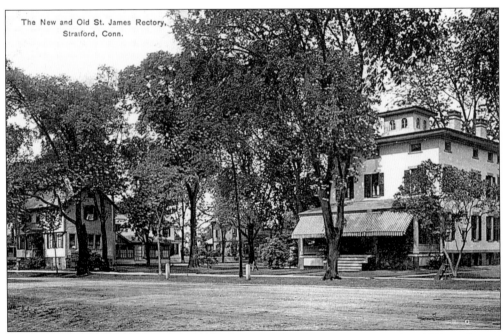

The New and Old St. James Rectory, Stratford, Conn.

The first step in the construction of St. James's new church was to remove the old Beers house, which had been serving as the rectory from the corner lot (left). The large mansard-roofed house next door, built for publisher Jesse Olney, became the new rectory.

When lightning destroyed the third Congregational meetinghouse on Watch House Hill in 1784, the fourth church was built on Smithshop Hill. It was typical of the time—made of post-and-beam construction with a steeple at the east end and the pulpit in the middle of the north side. In this building, the Declaration of Independence was read and the creation of the Constitution was announced.

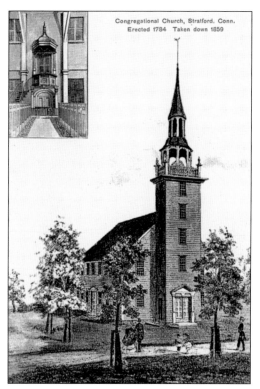

Congregational Church, Stratford, Conn.
Erected 1784 Taken down 1859

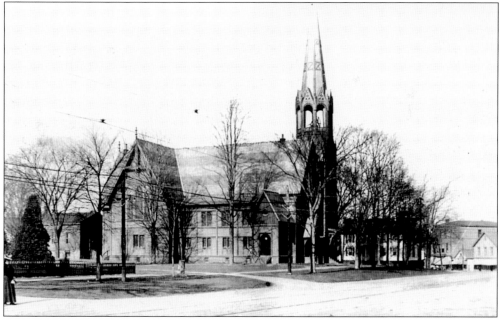

In 1859, when the Congregationalists learned that the Episcopalians were building a new church, they decided to build an even larger church of their own with a more famous architect, Leopold Eidlitz. When they learned the cost, the members cut the height of the building and eliminated the parish house from the budget. Built in true Carpenter Gothic style and painted in earth colors, the building was magnificent. It has since been renovated.

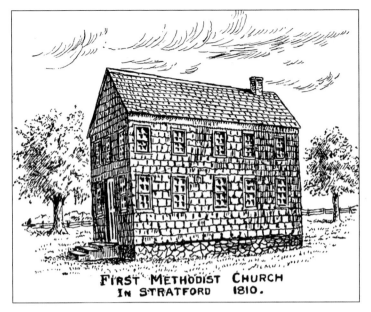

FIRST METHODIST CHURCH
IN STRATFORD 1810.

After Jesse Lee preached in Stratford in 1789, his listeners formed a Methodist congregation. Their first edifice was raised on April 5, 1810. When the Methodists built a new Grecian-style church down the street, the old church, on the site where a new firehouse is now under way, became the pork factory, where salted pork was put in barrels for export.

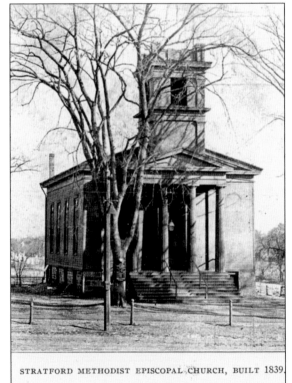

STRATFORD METHODIST EPISCOPAL CHURCH, BUILT 1839.

In 1839, the second Methodist church was opened on land donated by Thaddeus Peck, near where the Methodists' new graveyard (Union Cemetery) stood. As a final touch, member Hamilton Burton planted two elm trees, which grew for 100 years.

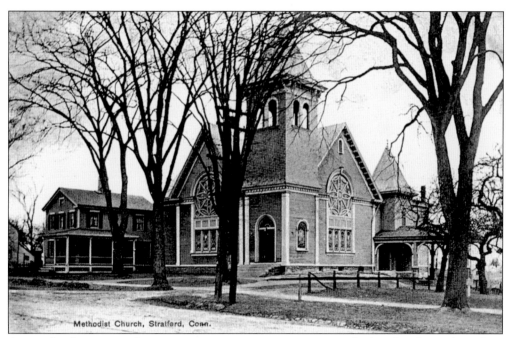

Methodist Church, Stratford, Conn.

As membership increased, in 1903 it was time to erect a new Methodist church. Banker Elliott Peck, who had an architectural degree from Yale, designed the larger church, using sketches from the Methodist national headquarters as guides.

2600 Main Street
Stratford, Connecticut 06497

On the same Main Street site as the last two Methodist churches, an ever-growing congregation has erected a new edifice to take them forward into the 21st century.

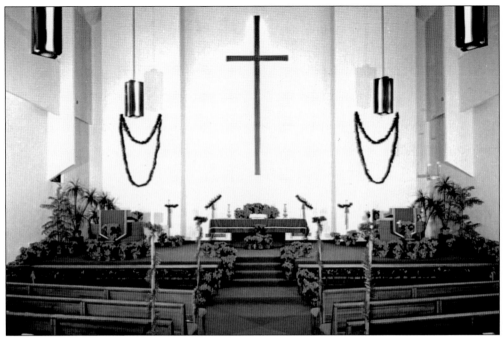

The sanctuary of the modern Methodist church is simple and undistracting. During the Lenten season, the only decorations are young palms.

When the Stratford Baptist Church outgrew its place of worship on Broadbridge Avenue (the same church the Catholics abandoned in 1914), its members sought a larger replacement. They found a church building at a U.S. Air Force base in Goldsboro, North Carolina, and moved it to Huntington Road at Paradise Green. After the outside was resheathed and the columned entry was added, the building was unrecognizable as the military chapel it had been.

Five

BUSINESS AND TRANSPORTATION

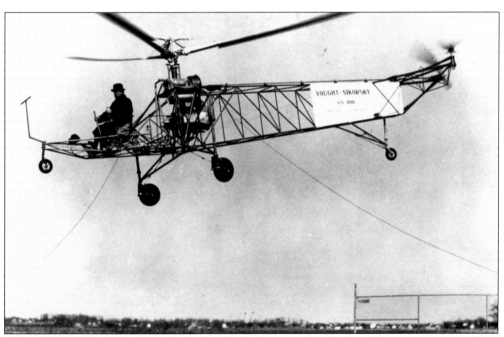

The Vought-Sikorsky VS-300 was the world's first practical helicopter, first flown on September 14, 1939, in Stratford. Here, its creator, Igor I. Sikorsky, is at the controls, wearing his famous fedora hat.

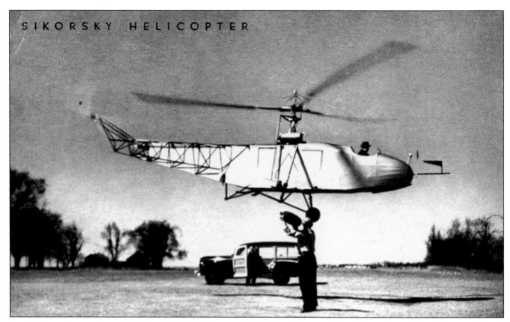

Aviation pioneer Igor I. Sikorsky built the world's first four-engine aircraft, evolved international flight with his flying boats, and developed the world's first practical helicopter. Here he hovers the VS–300 while an associate demonstrates changing a tire.

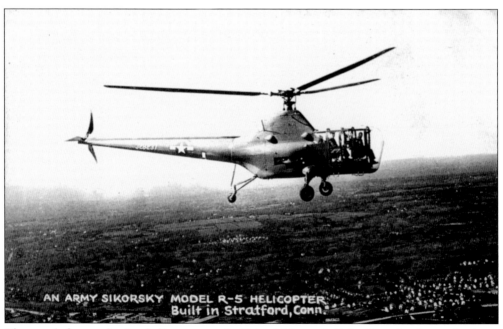

AN ARMY SIKORSKY MODEL R–5 HELICOPTER
Built in Stratford, Conn.

The army's first production helicopter was the R4, which was built by Sikorsky. Later, the Army R5 (also called Sikorsky S51, Navy HO3S) went into quantity production.

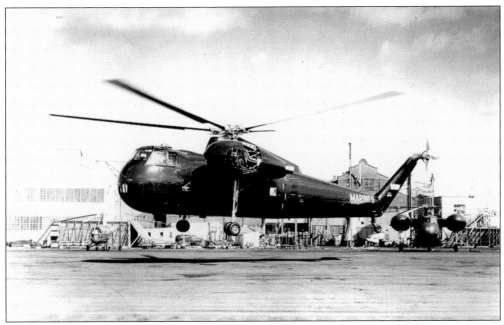

In 1951, Sikorsky won a contract for the S-56 (HR2S-1, H-37), which was five times the size of any previous helicopter. With two R2800 engines, a five-bladed, 72-foot-diameter rotor, clamshell doors, and a ramp, it could carry a platoon of troops or a jeep and trailer. Over 100 of them were built.

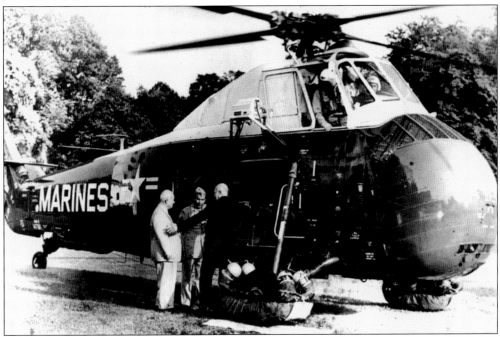

The S-58 (HSS-1, H34) first flew on March 8, 1954. Dwight Eisenhower was the first president to travel by helicopter. When Nikita Khrushchev, seen here with the president, admired one, Ike gave him two, one of which was studied intensely by the Soviet Union's helicopter expert, Michiel Mil. More than 1,500 were built in Stratford as well as Great Britain, France, and Japan.

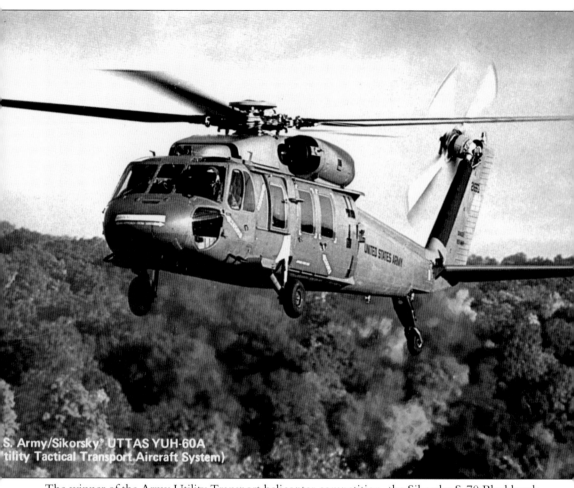

S. Army/Sikorsky UTTAS YUH-60A
tility Tactical Transport Aircraft System)

The winner of the Army Utility Transport helicopter competition, the Sikorsky S-70 Blackhawk became the Army H-60. It was first flown on October 17, 1974. Hundreds have been built for U.S. and foreign military services. The Blackhawk has become the standard helicopter of the 21st century.

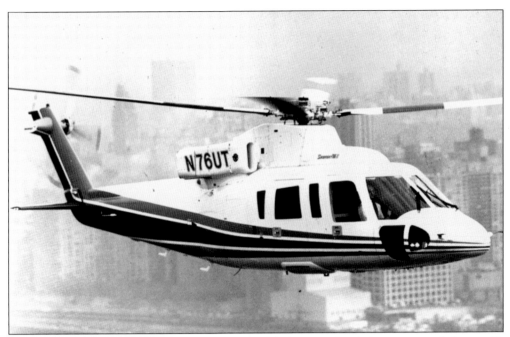

The Sikorsky S-76 is a 12-passenger commercial helicopter that is in use around the world. This one, a United Technologies Corporation corporate helicopter, is approaching a midtown Manhattan heliport.

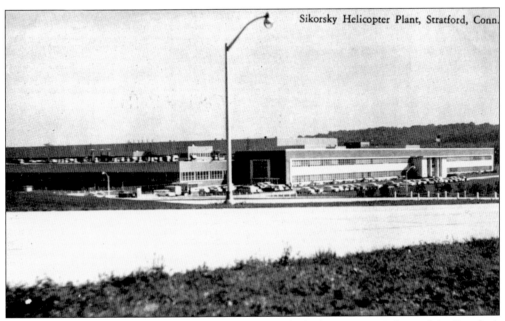

Sikorsky Helicopter Plant, Stratford, Conn.

The main plant and headquarters of Sikorsky Aircraft, built in 1955, is located in Stratford. A helipad near the front entrance serves visitors, and a large heliport behind the building is used to test and deliver aircraft built in the factory.

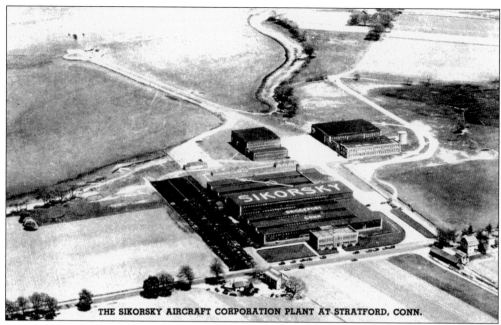

THE SIKORSKY AIRCRAFT CORPORATION PLANT AT STRATFORD, CONN.

In order to test its flying boat aircraft, Sikorsky Aircraft moved to Stratford from Bridgeport. The factory was completed in 1929 on farmland at the Housatonic River. The front office is on Main Street. A seaplane ramp extends out into the river, and an engineering building and hangar sit along Sniffen's Lane. As soon as the factory was in place, Sikorsky became a division of the United Aircraft & Transport Corporation.

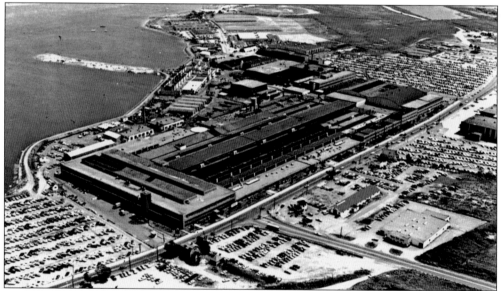

In 1939, Chance Vought joined Sikorsky to form the Vought-Sikorsky Division of the United Aircraft & Transport Corporation. The factory grew to 12,000 employees during World War II, and some 10,000 F4U Vought Corsairs were built. After Sikorsky moved to Bridgeport and Vought moved to Texas, the army moved AVCO Corporation's Lycoming Division into the plant; it became the leading producer of gas turbine engines for helicopters. Engines for the Abrams tank were also built here.

84

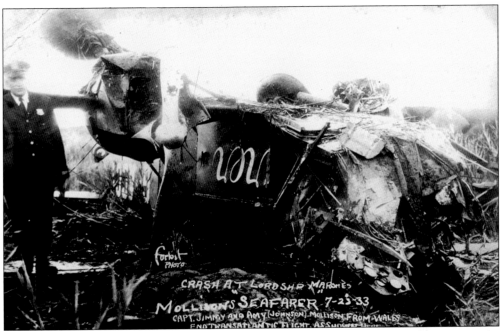

On July 23, 1933, Jimmie and Amy Mollison were headed for Floyd Bennett Field from Wales in an attempt to set a long-distance record. It was not to be. After sundown, they radioed that they were low on fuel. They made a downwind nighttime landing at the Bridgeport Airport in Stratford, spent the night at Bridgeport Hospital, and were flown to New York the next day by Igor Sikorsky and Dr. Luther Heidger. The airport was renamed Mollison Airport after the team that crashed there.

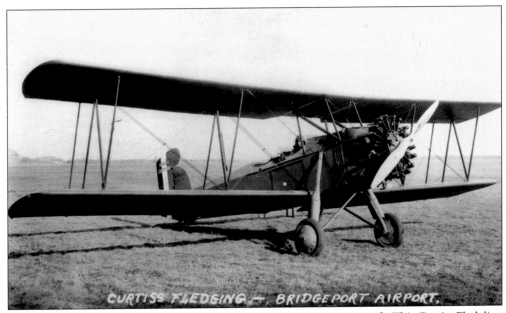

Mollison Airport was unpaved for years but was busy with private aircraft. This Curtiss Fledgling was typical of the aircraft based there in the 1930s.

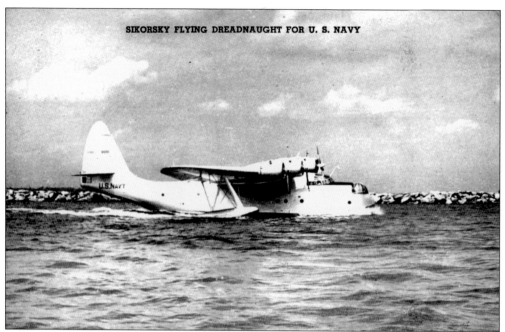

SIKORSKY FLYING DREADNAUGHT FOR U. S. NAVY

The last Sikorsky flying boat design was built as the Navy XPBS-1 patrol bomber in 1937. Powered by four Pratt & Whitney twin wasp engines, it was the navy's largest aircraft to date. It did not go into production; instead, three copies of a 32-passenger civilian variant were built as VIP transatlantic transports for use in World War II.

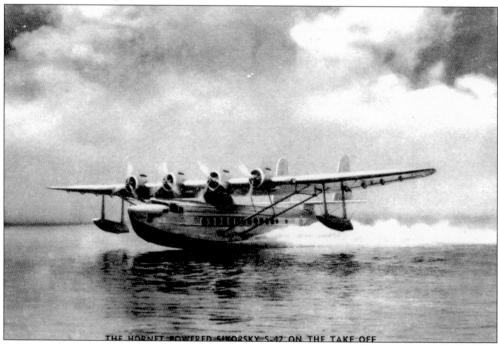

THE HORNET-POWERED SIKORSKY S-42 ON THE TAKE OFF

With a 150-knot cruise speed, a 1,200-mile range, and a 32-passenger cabin, the Sikorsky S-42 flying boat was far ahead of its time. On August 1, 1934, in a single eight-hour flight, it captured eight world records and made the United States the foremost holder of aviation records.

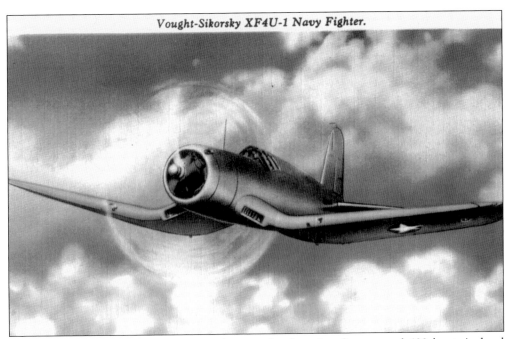

In 1940, the Vought-Sikorsky XF4U-1 became the first aircraft to exceed 400 knots in level cruise flight.

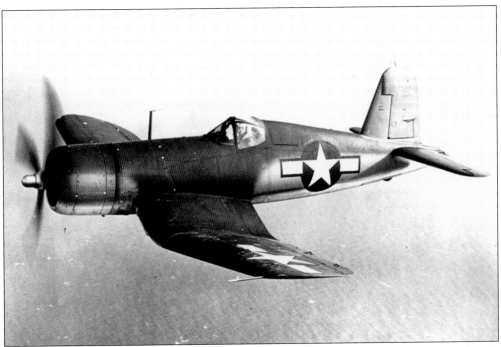

During World War II, Vought Corsairs rolled out of the factory at a rate of eight per day. In the war in the Pacific, Japanese pilots called the Marine Corps F4Us "whistling death." Vought, Goodyear, and Brewster Aircraft built more than 12,000 of them.

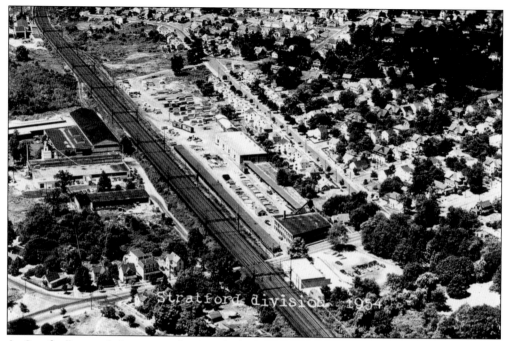

As Stratford's population grew, the Stratford Lumber Company became the major source of building material. After World War II, the Burritt Lumber Company took over the West Broad Street yard.

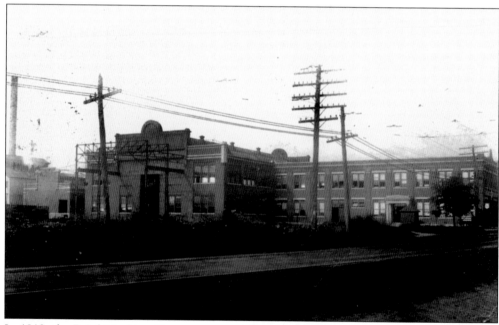

In 1912, the Baird Machine Company moved from Oakville into its new Stratford factory on Stratford Avenue. Baird made machinery for forming wire and sheet-metal articles, such as pins, hooks, and springs, and built tumbling and polishing barrels. At one point, the plant manufactured lawn tractors. It was the first large factory in Stratford.

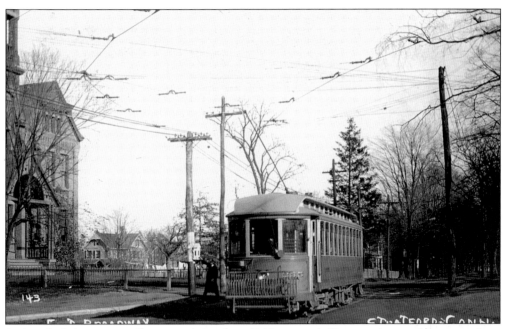

At Stratford Center, a trolley car arriving from Bridgeport via Barnum Avenue has swung from Main Street onto East Broadway and will head across the river to Milford and the interurban line that runs along the shore to New Haven.

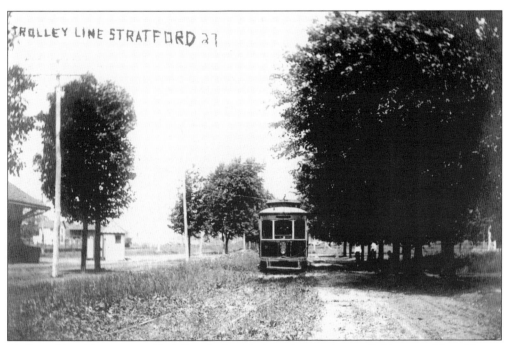

Trolleys like this one provided Stratford with intercity service to Bridgeport, New Haven, and Shelton.

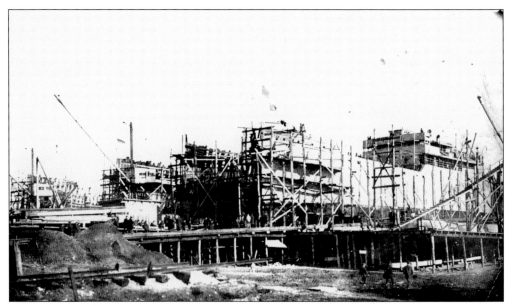

During World War I, the Shipping Board tried to supplement the country's shipyards by building small, 267-foot wooden freighters in temporary yards. Housatonic Ship Building was chartered in 1916 to build five wooden ships in a yard north of the railroad. The work went slowly; the war was over before the first ship was launched.

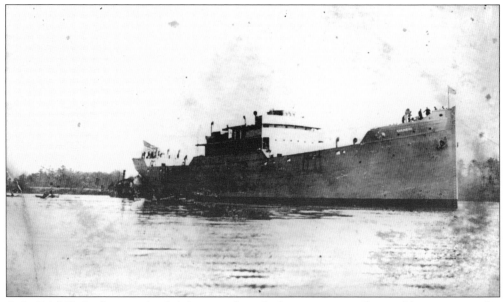

Only *Fairfield*, the first wooden freighter, was launched at Housatonic Ship Building in 1918. This is the second, *Ganeri*, seen just off the ways on January 30, 1919.

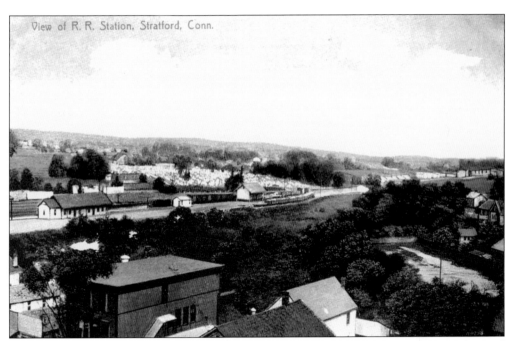

By 1900, the railroad had become the New York, New Haven & Hartford, and it was in financial trouble. Nevertheless, J. P. Morgan was four-tracking the line and removing crossings. The railroad station is seen here from the Congregational church steeple just after 1900. It has been moved to Main Street, and sidings have been added.

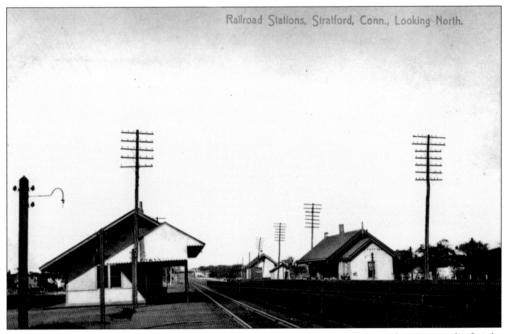

Railroad Stations, Stratford, Conn., Looking North.

Looking east, we see a new westbound station, a four-track line, an eastbound station, and a freight station. This photograph was taken after 1900. The line is not electrified, so it is before 1911.

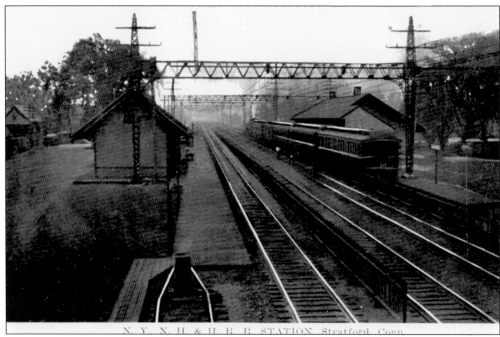

N. Y. N. H. & H. R. R. STATION Stratford Conn.

This photograph, looking west, was taken shortly after electrification. Here, we see that Stratford's station is part of an efficient commuter railroad. The train from Waterbury has joined the main line at Naugatuck Junction (Devon) and is loading for Bridgeport. The engine is probably an 800 series 4-4-0, a little kettle built years before.

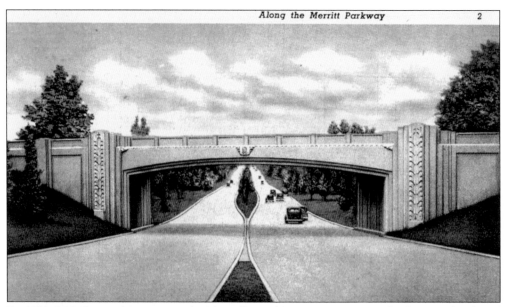

Along the Merritt Parkway 2

By 1930, U.S. Route 1 was saturated with traffic, and it was time to expand. The state developed a new limited-access parkway across Fairfield County. It was still the days of the Sunday afternoon drive, so the objective was not speed, but to provide a pleasant ride. On the Merritt Parkway, named for Congressman Schuyler Merritt, every bridge was a different art object, and the speed limit was 35 miles per hour. The last section, the Housatonic Bridge, was opened in 1940.

Six

COMMUNITY ACTIVITIES

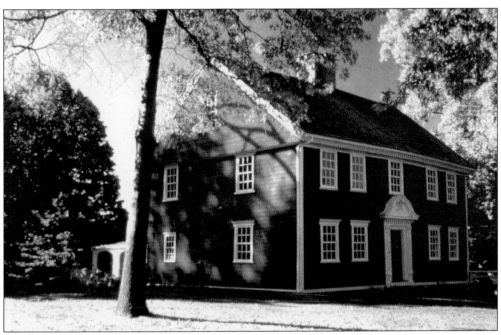

Militia captain David Judson built a large home on Academy Hill in the mid-18th century. The Captain David Judson House is now owned by the Stratford Historical Society. Together with a museum building in the rear, it provides a view of life in Stratford over the last four centuries.

In the 1890s, Academy Hill was a bucolic green, unspoiled by development. A dirt highway led diagonally across the common, and another led up the hill to the east. The academy for which the hill was named was gone; a monument to military men stood on the hill's crest. Graceful elms dotted the landscape. In the foreground is the Captain David Judson House.

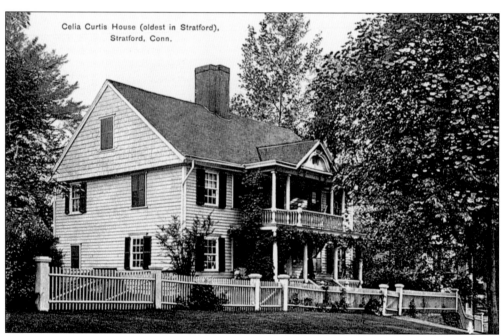

In 1890, the owner of the Captain David Judson House added a veranda to modernize it. The veranda remained in place until Celia Curtis gave the house to the Stratford Historical Society in 1925.

94

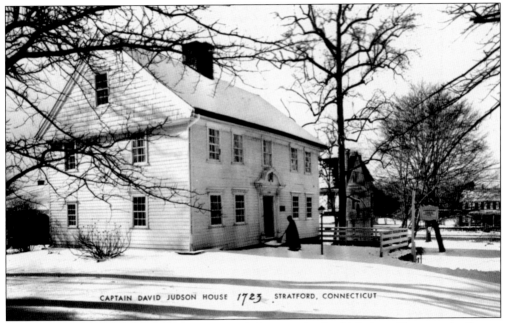

CAPTAIN DAVID JUDSON HOUSE *1723* STRATFORD, CONNECTICUT

Since 1925, the historical society has restored the Captain David Judson House to its former appearance both inside and out. The pediment above the door has been returned to the configuration it had when the house was built.

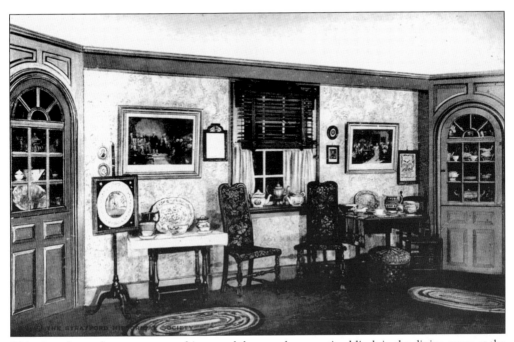

This view shows the two corner cabinets and the wooden venetian blinds in the dining room at the Captain David Judson House as they were in the period of the Revolution. This and the following interior photographs were taken shortly after the historical society was founded in 1925.

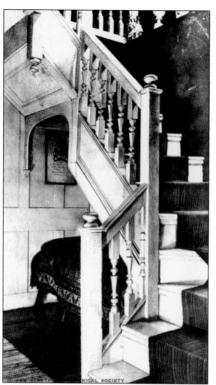

This ornate stairway in the "porch" of the Captain David Judson House was built by a master carpenter. An attic stairway has "JB 1768" painted on it. Since carpenters did not sign their work with paint, it is assumed that these are the initials of an early house painter.

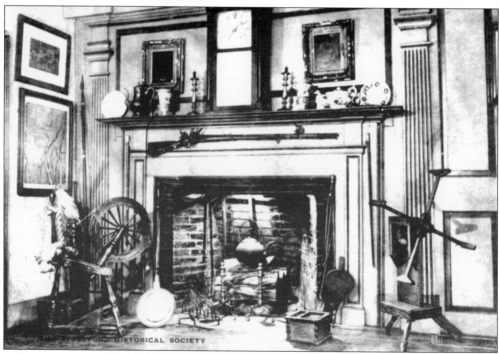

In the 1920s, the dining room at the Captain David Judson House displays household articles from the Revolutionary War period. The fireplace wall exhibits fine paneling, which was installed in the early 19th century.

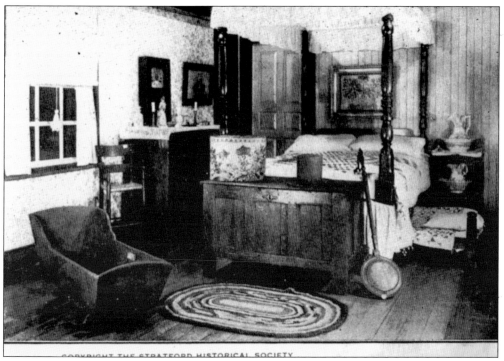

Again in the 1920s, the Captain David Judson House's dining room chamber (the bedroom over the dining room) has 18th- and 19th-century equipment on display. The cradle and the warming pan are from the 1700s; the pitcher on the wash stand may have come from China aboard a 19th-century Stratford sea captain's ship.

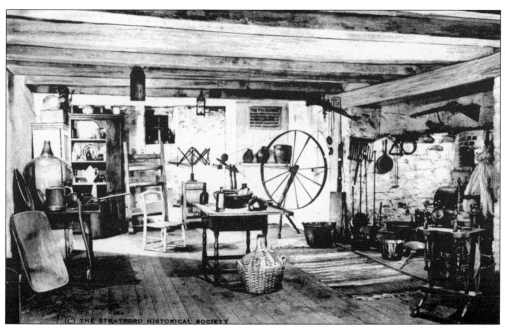

In the 18th century, the Judson family owned three slaves who lived in the basement. The basement room had the largest fireplace in the house, which was used for cooking in the hot summer.

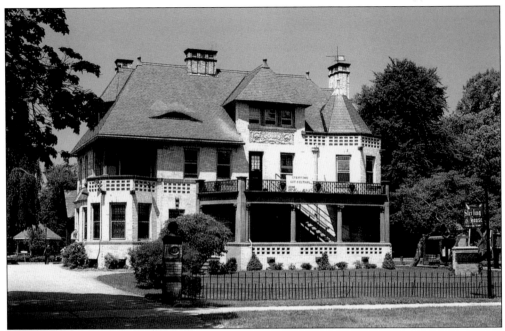

After John Sterling Jr. graduated from Yale and from Columbia Law School, he was an early corporate attorney. As the lawyer for robber barons Daniel Drew, Jim Fiske, and Jay Gould, he became a wealthy man. In 1886, John had this house built for his mother and his sisters. Its architect was Bruce Price, who designed the Canadian Pacific Railway's immense hotels.

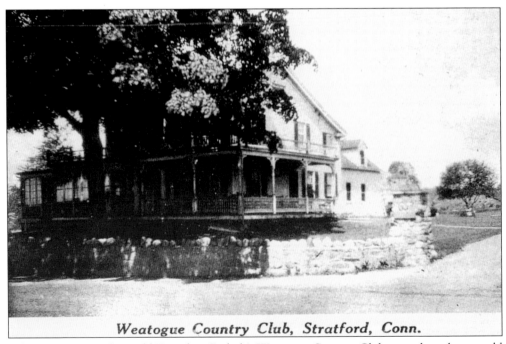

Weatogue Country Club, Stratford, Conn.

When Minor Knowlton sold Knowlton Park, his Weatogue Country Club moved north to an old farm at Main Street and East Main. In 1923, the club renamed itself Mill River Country Club.

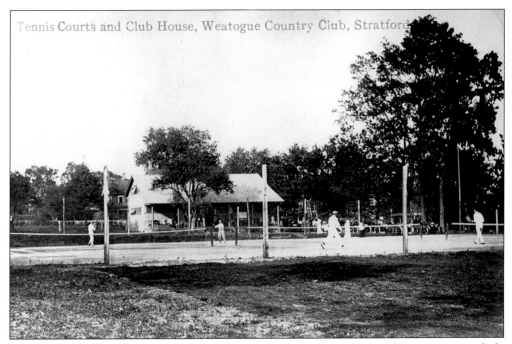

Tennis Courts and Club House, Weatogue Country Club, Stratford

The Weatogue Country Club opened in 1916 with six tennis courts in addition to a nine-hole golf course.

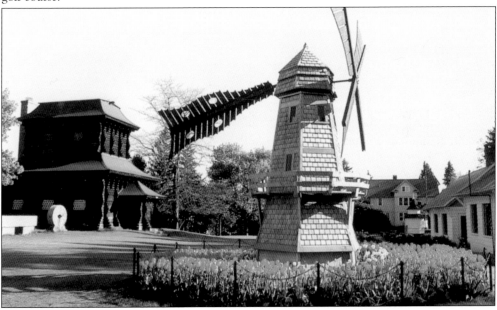

In 1949, when David Boothe died, the 32-acre Boothe homestead, which had been in the family since 1663, became a town park. In 1913, David and his only brother, Stephen, began building curious new features on the property. They added a clock tower to the barn and built a "coliseum," an outdoor basilica with organ house, and a blacksmith shop. Behind a windmill is their "technocratic cathedral," a monument to the depression. Its timbers were as flat as depression finances and the wood was as red as depression ledgers, David explained. Like most depression projects, the building was never completed.

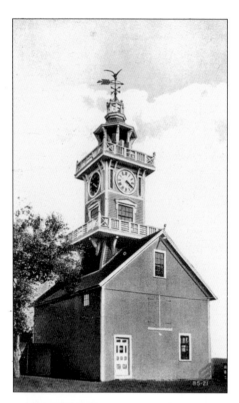

David and Stephen Boothe's first project was this clock tower. In 1913, the boys swapped an electric carpet sweeper for an old clock tower containing a clock with wooden works. They replaced the works with a new Howard clock and installed the tower, complete with Westminster chimes and five massive bells, on their hay barn. When neighbors complained that the chimes were waking their chickens, the town slapped a tax on the tower. The Boothes swore that they would never give the town the time of day again, and they did not. But when they died, they left the whole homestead to the town.

Boothe Park in Putney contains two old house museums, a clock tower, the "coliseum" meeting hall, an outdoor worship area with pulpit and organ, a blacksmith shop, a tollbooth, a railroad station, an astronomical observatory, and numerous gardens and picnic spots. Here we see the park from Main Street.

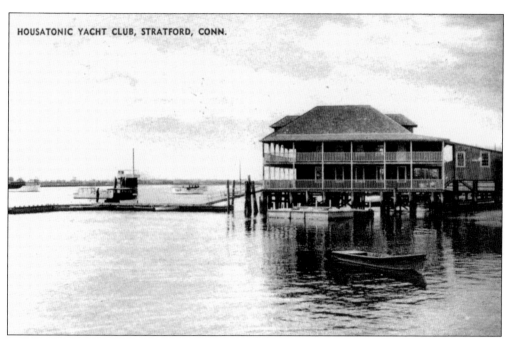

HOUSATONIC YACHT CLUB, STRATFORD, CONN.

Stratford's second yacht club was the Pootatuck, formed in 1898 and based in the old Lewis Oyster Company building until this clubhouse was built in 1917. Sailors belonged to the Housatonic Boat Club; powerboaters ran the Pootatuck. This postcard incorrectly identifies the Pootatuck Yacht Club.

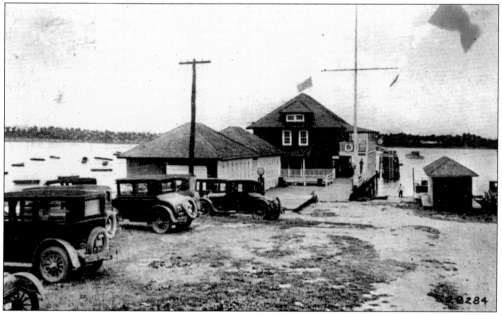

In 1928, the Pootatuck Yacht Club building, built by contractor Filmer, stood on pilings in front of a pair of locker buildings; members' yachts swung to moorings in the stream. Today the clubhouse has been moved toward shore, and boaters keep their boats in berths in the river.

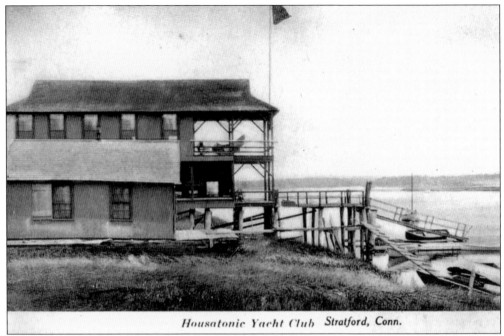

Housatonic Yacht Club Stratford, Conn.

Built in 1887, the Housatonic Boat Club is now the oldest yacht club in the state. It stands on pilings at the edge of what was once a salt marsh, with a walkway from the shore. The smaller building seen here is the men's bathhouse, set on a floating barge.

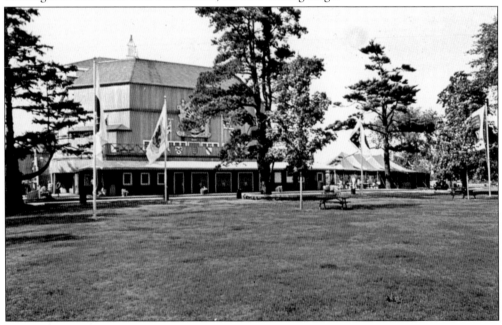

In July 1955, Lawrence Langner's American Shakespeare Theatre opened with *Julius Caesar*. For years, famous actors—including Fritz Weaver, Hal Holbrook, Morris Carnovski, Jessica Tandy, Raymond Massey, Christopher Plummer, James Earl Jones, Katharine Hepburn, Robert Ryan, Larry Gates, June Havoc, and Alfred Drake—came to Stratford each summer to play Shakespeare and other classics at the theater on the Housatonic.

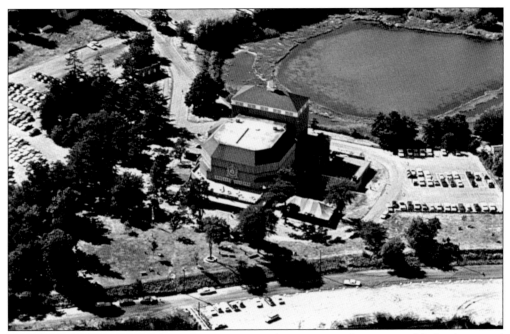

The 14-acre campus of the American Shakespeare Theatre rang each summer with the shouts and songs of actors, who entertained picnickers on the lawn until bells summoned the audience into the theater. From the shaded lawn, visitors could see down the river and across the sound.

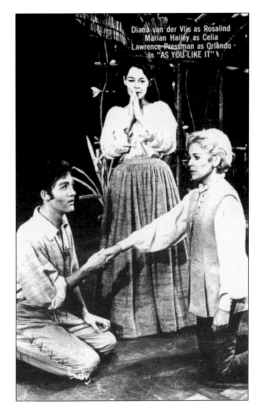

The 1968 rendition of *As You Like It* (which has been performed three times at the theater) had Diana van der Vlis as Rosalind, Lawrence Pressman as Orlando, and Marian Hailey as Celia. It received mixed reviews.

103

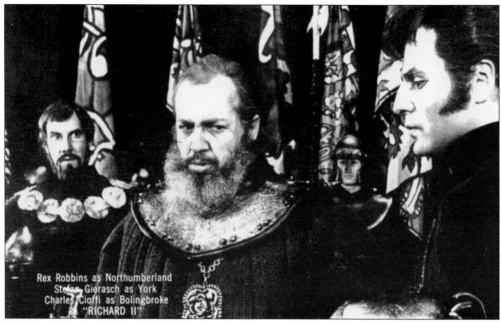

Rex Robbins, Stefan Gierasch, and Charles Cioffi appear here in a scene from *Richard II,* directed by Michael Kahn. Donald Madden's portrayal of Richard was labeled "provocative" by the critics.

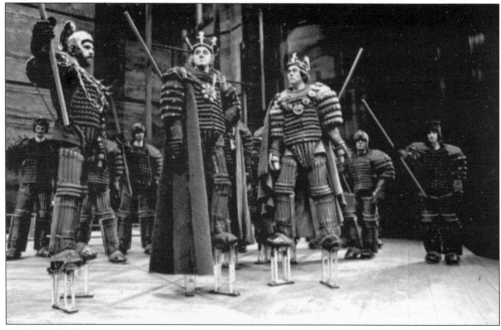

In *Henry V,* director Michael Kahn stood the French court on stilts to represent its invulnerability to the English. The French courtesans spoke French among themselves, which was translated by actors on the sides of the stage.

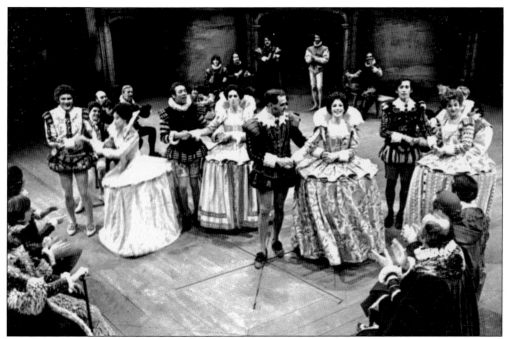

This dance scene is from *Much Ado About Nothing*. The 1969 offerings were quite diverse, with *Much Ado About Nothing* (a comedy), *Hamlet* (a tragedy), and *Henry V* (a history), along with Chekhov's *The Three Sisters*.

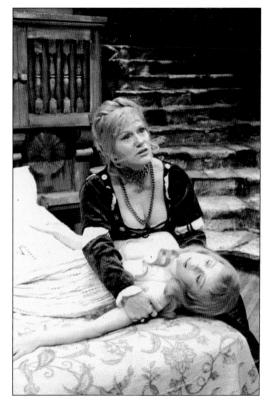

The 1970 performance of *Othello* got good reviews. One critic called Moses Gunn "the best Othello I have ever seen." Lee Richardson's Iago was well played. Here Emilia (Jan Miner) laments the slain Desdemona, played by Roberta Maxwell.

In 1971, Michael Kahn directed *The Merry Wives of Windsor*. Dr. Caius (Robert Statel) confronts Simple (Josef Warik) while Dame Quickly (Jan Miner) observes. To reduce production costs, most members of the company acted in more than one play.

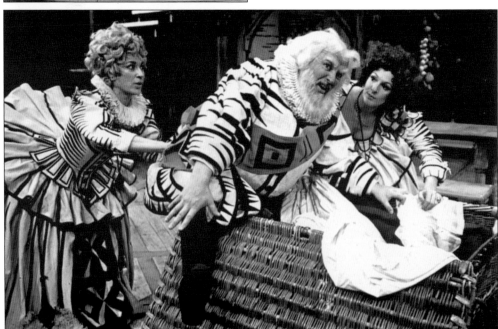

In *The Merry Wives of Windsor,* the scene in which Falstaff (W. B. Brydon) attempts to hide in a basket stole the show. After several tries at stepping into the basket, he lay on a table and rolled in.

In 1973, director Michael Kahn's *Measure for Measure* (seen on this postcard), *Macbeth,* and *The Country Wife* were good fare in a time when America was recovering from a divisive war and was engaged in the Watergate affair. The plays dealt with the complexities of government and the corruption of power.

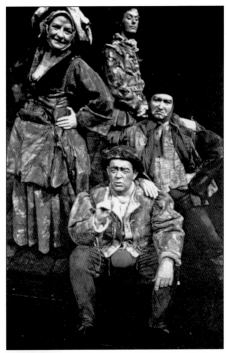

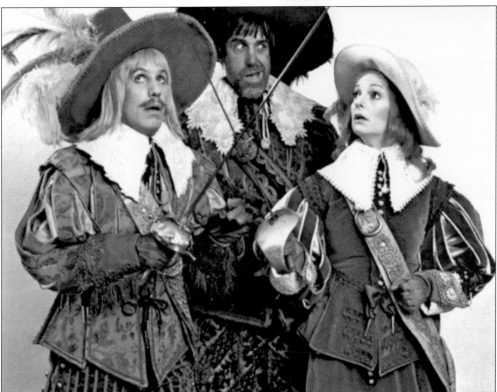

Malvolio (Philip Kerr), Uncle Toby (Fred Gwynne), and Viola (Carole Shelly) plan a scheme together in the 1974 production of *Twelfth Night*.

This Robert Treat sketch of the American Shakespeare Theatre area shows, from left to right, the cottage occupied by Katharine Hepburn during her 1958 and 1960 performances at the theater, the house rented by Jessica Tandy when she played Lady Macbeth, the home of Caroline Davenport (who acquainted Lawrence Langner with the property), the house where Spencer Tracy stayed when he was visiting Hepburn, and the theater itself.

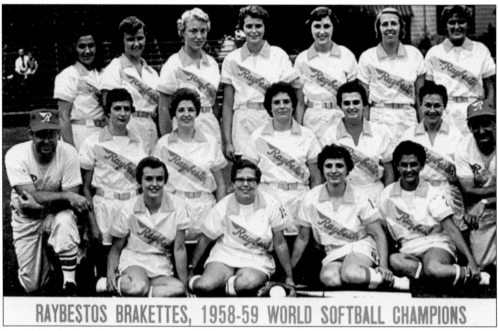

RAYBESTOS BRAKETTES, 1958-59 WORLD SOFTBALL CHAMPIONS

By 1959, the Raybestos women's softball team, organized in 1947, had amassed 434 wins and 83 losses. Undefeated in 12 straight world tournament games, the Stratford team became the Women's World Softball Champions in the 1958–1959 season.

Seven

THE ARMY
COMES TO TOWN

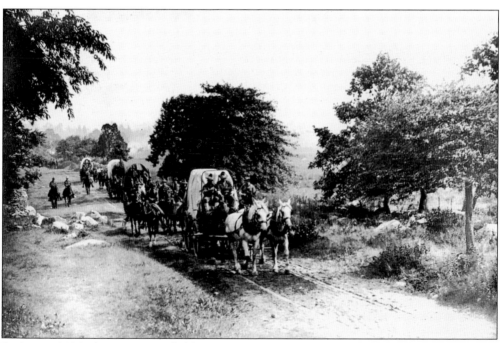

In August 1912, the U.S. Army held war maneuvers in the Stratford area to practice defending New York from foreign aggressors. The invading Red Army's headquarters was across the Housatonic in Milford; the defending Blue Army, under Gen. Tasker Bliss, operated from "Camp Walter N. Lee" near Paradise Green in Stratford. The invaders ended up winning the games, and New York was lost.

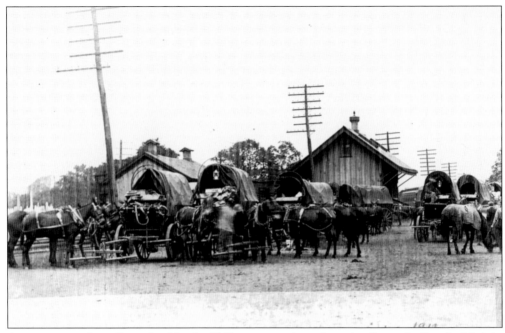

Army troops and supplies arrived for the 1912 war games by train, unloading at the Stratford freight yards. From there, wagons drawn by army mules took supplies up Main Street to headquarters at Camp Lee.

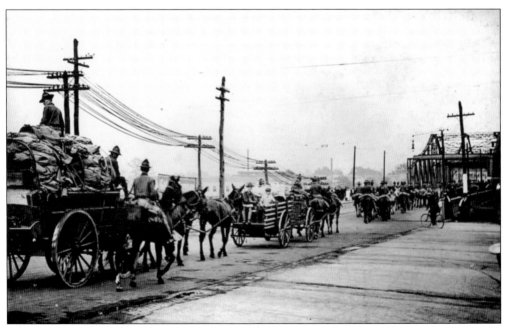

Troops and gear destined for the invading Red Army headed across Washington Bridge for Milford. Supplies went on mule-drawn wagons, the cavalry rode their horses, and the infantry marched.

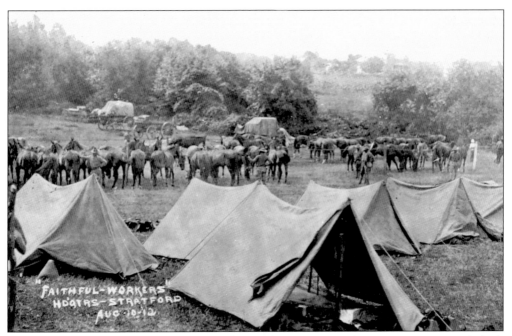

By August 10, Camp Lee was set up in Wilcoxson's pasture near the green, tents were pitched, and the mules and horses were turned out to graze.

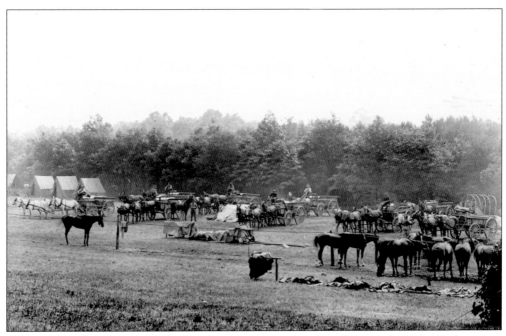

General Bliss's headquarters and officers' tents were set up and made ready for action in the center of the grounds in Stratford.

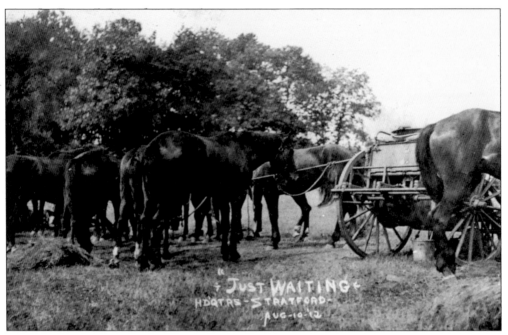

On August 12, troops and animals at Camp Lee continued to wait for more equipment to arrive. Bringing it the two miles from the railroad was a slow process.

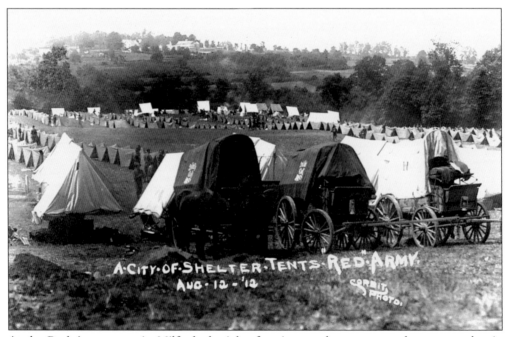

At the Red Army camp in Milford, the job of setting up the camp was the same as that in Stratford. The larger tents were used as headquarters, operational facilities, and officers' quarters.

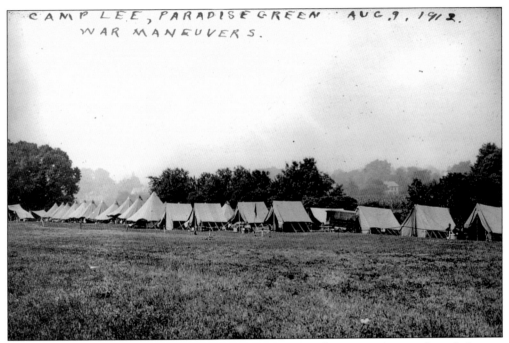

On August 9, 1912, the mess sergeants (seen at center) are busy preparing meals at their tents while the troops are off on maneuvers. The field in the foreground is ready for the three airplanes present at the exercise, the first aircraft ever used in the field by the army.

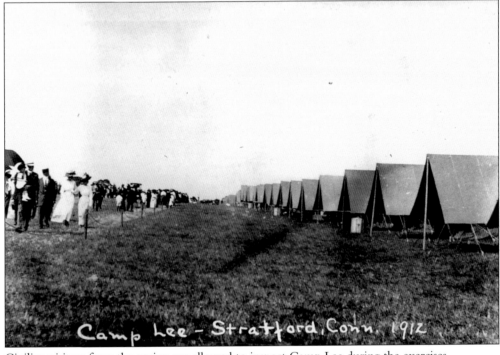

Civilian visitors from the region are allowed to inspect Camp Lee during the exercises.

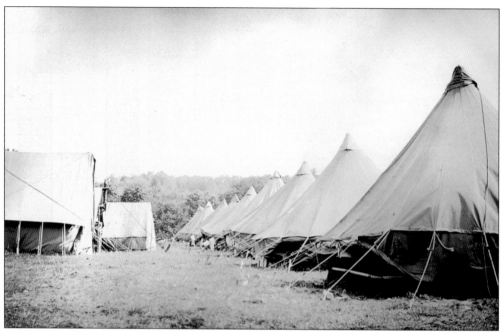

Rows of tents are set up on Walter Wilcoxson's farm at Paradise Green during the army's August 1912 maneuvers. Foreign military men are allowed to visit as observers.

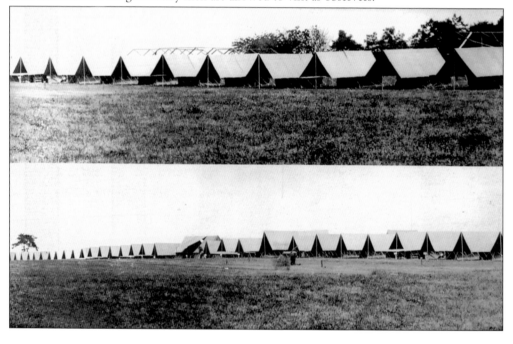

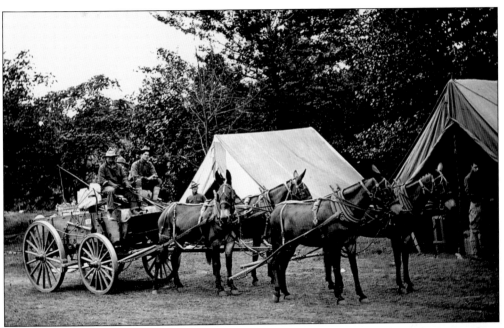

For three days, the mule wagons continued to deliver supplies to the cooks at Camp Lee from the railroad station.

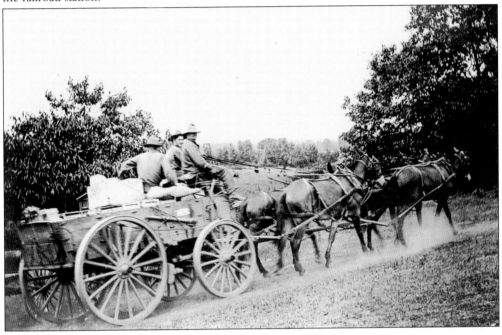

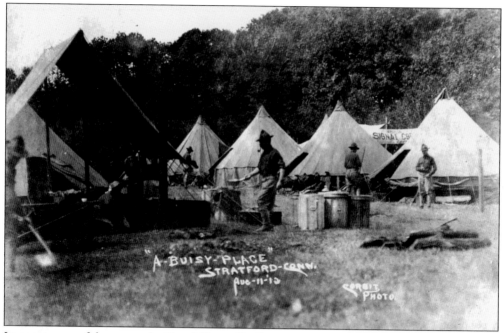

In one corner of the camp, the Signal Corps distributes messages to and from troops in the field. The three observation aircraft send wireless messages to headquarters for operational decisions. In another corner, cooks prepare mess for when the troops return to camp.

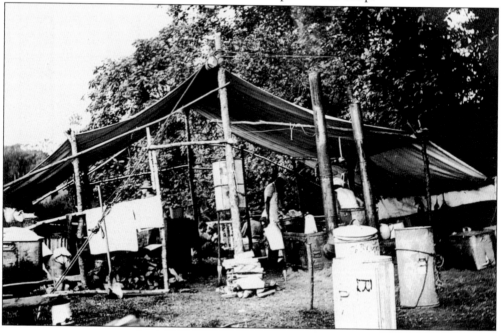

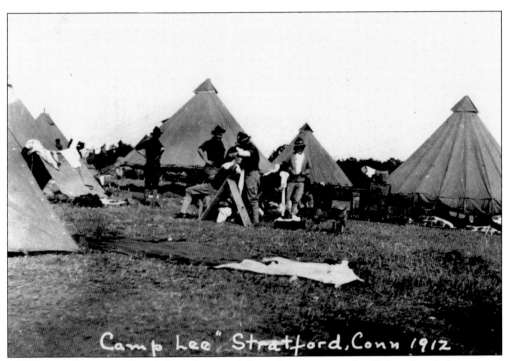

Above, signalmen take a break from their work for a photo opportunity. Below, hospital corpsmen wait for casualties from the field.

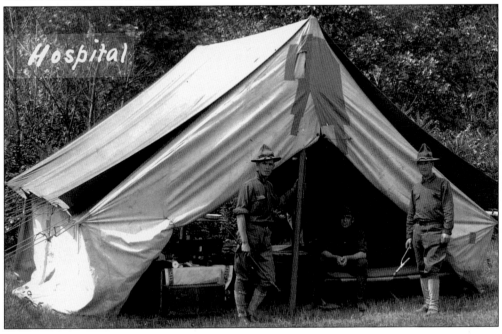

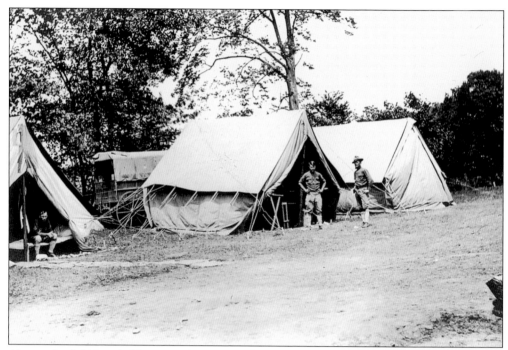

Above, the field hospital is empty; its personnel wait patiently for "wounded" to arrive. Below, in the umpire's tent, a radio operator waits for messages from the umpires in the field in order to assess the results of the Red and Blue maneuvers.

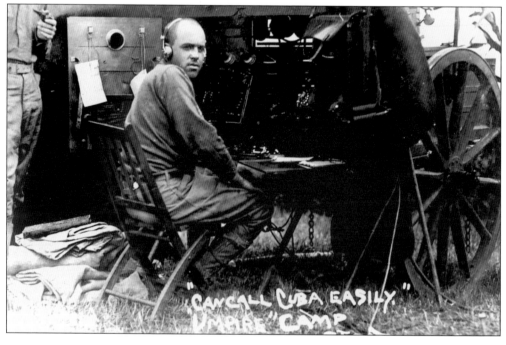

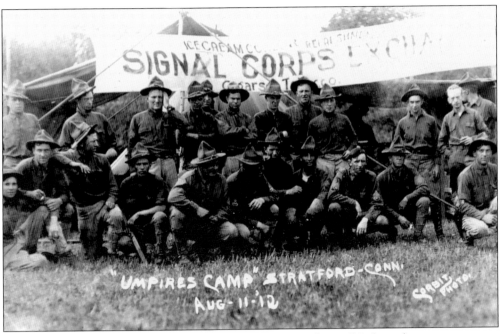

Above, the Signal Corps sign advertises "ice cream, cigars, tobacco." Below, the troops return to camp for food and relaxation after a day of skirmishes.

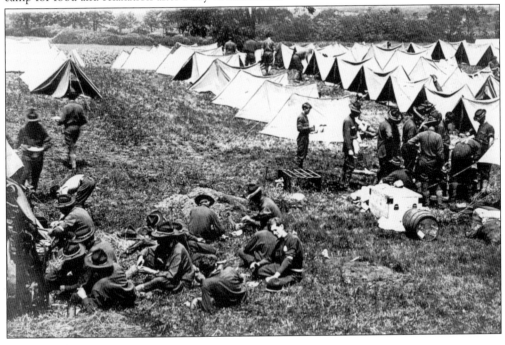

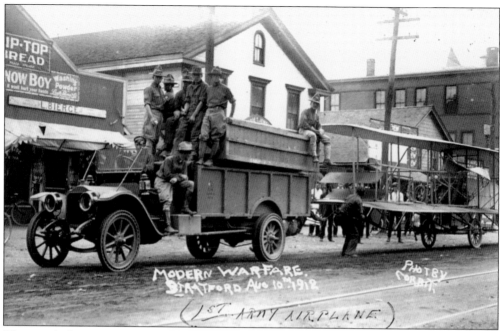

The army's first operational use of aircraft was for observation in its war games at Stratford in 1912. Above, the army's Wright Model B is towed through Stratford Center to a grass airfield at the green. Below, Beckwith Havens flies over the camp in his Curtiss. The third airplane at the exercise was a Burgess.

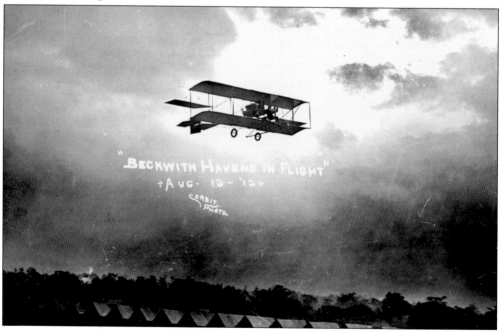

Eight

IN THE COUNTRY

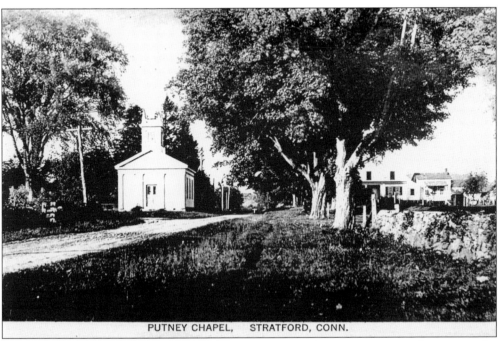

PUTNEY CHAPEL, STRATFORD, CONN.

Five miles north of Stratford Center were the farms of Putney. Because the trip to the Congregational church was arduous, the Putneyites built their own chapel in 1844 where Main and Chapel Streets now meet. Due to heavy auto traffic in the 1970s, the chapel was moved to Boothe Park, where it is still in use for funerals, weddings, and ceremonies.

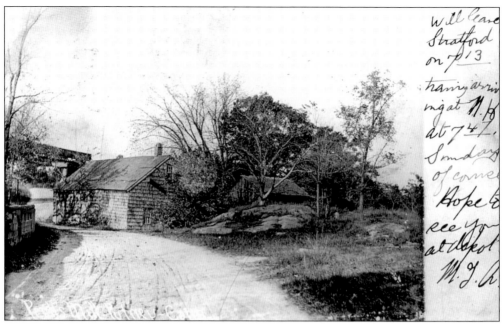

At Peck's Mill Pond on the road to Shelton stood "Uncle Eli" Wheeler's Mill, later owned by Wheeler's son-in-law Benedict Peck. The photograph actually shows two mills, the gristmill by the side of the road and the sawmill downstream. The mills ceased running in the late 1800s. The mills came down before 1927, when River Road became a concrete highway. Below is a view of a Putney farmhouse along the road *c.* 1900.

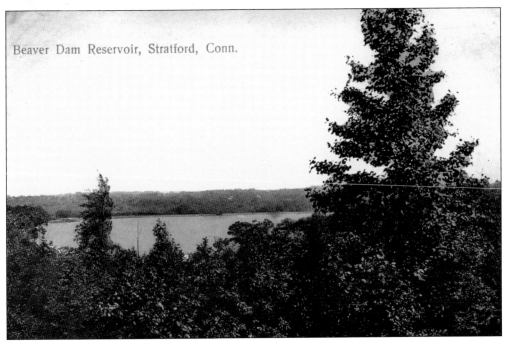

Beaver Dam Reservoir, Stratford, Conn.

Above is a photograph of the town's first public water supply, which flowed from the Beaver Dam Reservoir. In 1900, the Bridgeport Hydraulic Company laid a 12-inch pipe to downtown Stratford. The water was claimed to be the third-purest in the United States. Below is a view of Oronoque Village, a large adult condominium community that was built in the early 1970s on farmland in the north end of town.

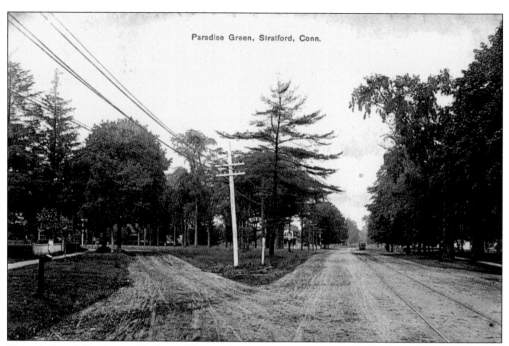

Paradise Green, Stratford, Conn.

Since industrialist Anson Phelps told Levi Curtis, "This must be paradise," the upper green has been called Paradise Green. In the 19th century, the one-room "new north" schoolhouse stood at the north end of the green, surrounded by grazing cattle. Tall elms shaded the lawns, and at one time a tennis court stood on the green. After the trolleys came in 1894, home builders dotted the lots with houses. The roads were paved in 1927.

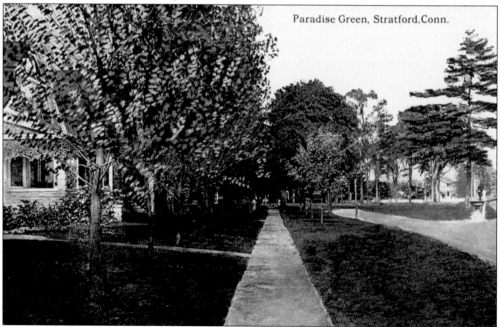

Paradise Green, Stratford, Conn.

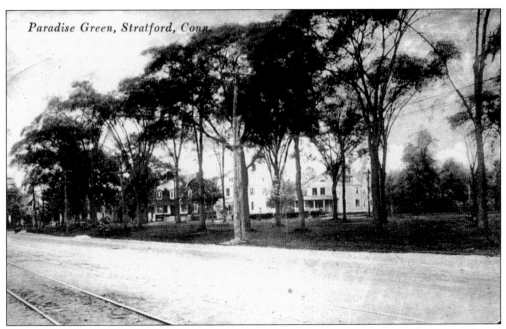

Paradise Green, Stratford, Conn.

These are two more views of Paradise Green in the early 1900s. Above are houses on lower Huntington Road as seen from Main Street. Below is a view of Paradise Green Place when the Brewsters lived in the house that is now Adzima's funeral home (left), and the Curtis sisters lived in the house that is now part of a drugstore and travel center (right).

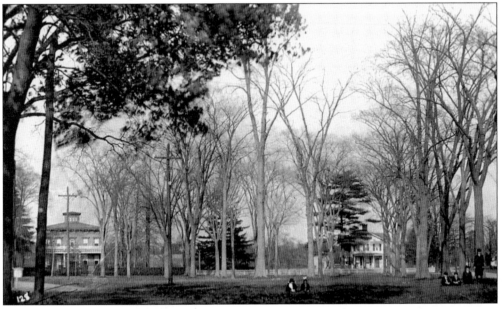

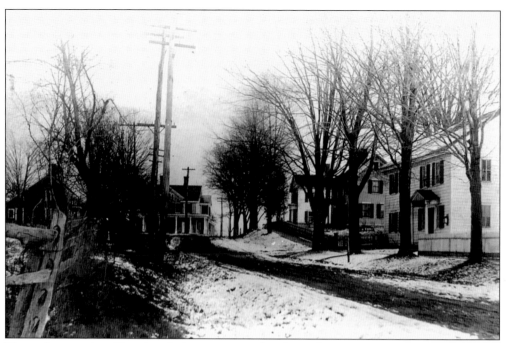

These photographs of Longbrook Avenue were taken long after it stopped being called Teaparty Lane. Above is a view looking east toward Elliott Peck's house in the distance. Some of the houses on the right have since been moved across the street to make way for large stores. Below, the view from Wells's house on Main Street consists largely of open fields.

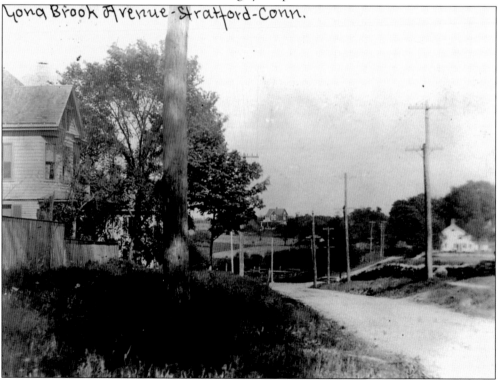

Long Brook Avenue - Stratford - Conn.

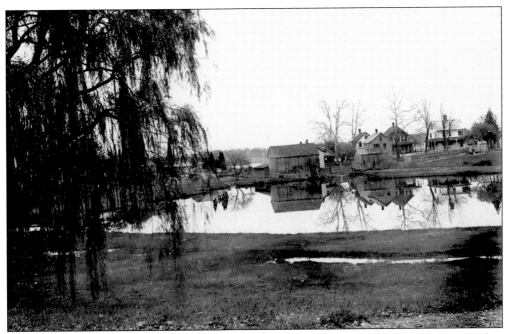

Above is a view of the pond that Captain Selby called Peet's Pond; we call it Selby's Pond today. Selby's has no feeder brooks, but it is connected to the river by a creek and is thus a highly saline body of water. It is located behind the American Shakespeare Theatre. Below, the pond called Fresh Pond (often corrupted to Frash Pond) is, interestingly, also a salt pond. It is situated near the Great Marsh and was once a great source of eels.

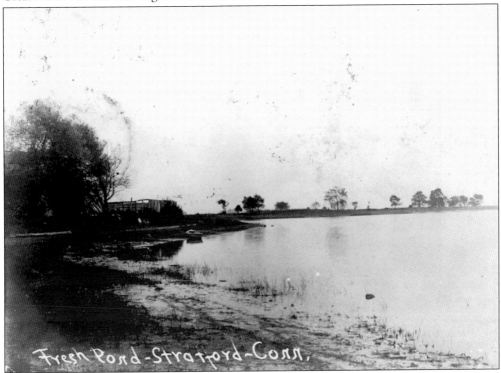

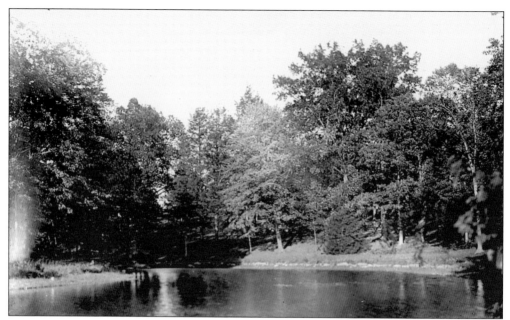

A 19th-century dam in Long Brook, seen above, created Judson's Pond, which provided water for making steam at Wood's Lumber Mill and ice for the Judson family. When Bill Brewster bought the pond, it took his name. At the time of this photograph, Ray Knapp, fishing from Brewster's canoe kept by their icehouse, was taking two-foot pickerel from the pond. Farmill River, seen below, was just what its name implied; it had 13 mills along its length. The last big mill, the paper mill near Pine Rock, burned down in 1907, but its dam is still there.

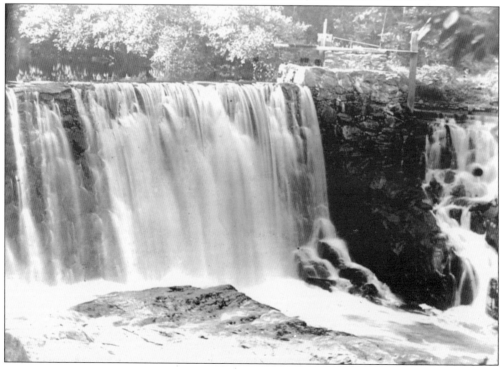